IMAGES
*of America*

# NEW YORK CITY
# JAZZ

On the Cover: Billie Holiday. This is the iconic photograph of Billie Holiday, perhaps singing "Travelin' Light" or "Good Morning Heartache," at the famous Club Downbeat on Fifty-second Street. William P. Gottlieb took this photograph. This was taken at the peak of Billie Holiday's career, and she was often referred to as "Lady Day," a nickname given to her by her good friend Lester Young. Billie Holiday will be remembered for her stellar voice, unique style, wonderful songs, the gardenias in her hair, and her dog Mister, a boxer who was always by her side. Her famous recordings of "I Can't Get Started," "Lover Man," and "Swing Brother Swing" and her own song "God Bless the Child" still sound timeless. (Courtesy of Library of Congress, William P. Gottlieb Collection.)

IMAGES
*of America*

# NEW YORK CITY
# JAZZ

Elizabeth Dodd Brinkofski
Foreword by Joe Cinderella

ARCADIA
PUBLISHING

Copyright © 2013 by Elizabeth Dodd Brinkofski
ISBN 978-0-7385-9914-4

Published by Arcadia Publishing
Charleston, South Carolina

Printed in the United States of America

Library of Congress Control Number: 2012952436

For all general information, please contact Arcadia Publishing:
Telephone 843-853-2070
Fax 843-853-0044
E-mail sales@arcadiapublishing.com
For customer service and orders:
Toll-Free 1-888-313-2665

Visit us on the Internet at www.arcadiapublishing.com

*This is dedicated to Richard and Elizabeth Dodd, my dad and mom, who shared all their stories about their adventures on Fifty-second Street. I was searching for and found the young, beautiful, and elegant couple whose eyes dazzled with excitement knowing that, at that moment, the stars all lined up and the world was theirs. All my love to Ted, Teddy, Anjelica, and Trent.*

# CONTENTS

# FOREWORD

It was a glorious time. It is no wonder that the heart of jazz found its pulse in NYC.

I had a marvelous career, playing for 25 years at Birdland and all the other jazz clubs on Fifty-second Street. Charlie Parker used to sit in the front row and watch. He told me he loved the way I played, saying, "Man, how do you get all of that sound out of them wires." Billie Holiday would hang at Birdland all the time. I thought she was the greatest.

I was the luckiest guy in the world. I met them all—Bill Evans, John Coltrane, Sarah Vaughan, Coleman Hawkins, Thelonious Monk, Miles, Dizzy—the list goes on forever. I loved Bill Evans; he was my favorite pianist. He looked like a movie star. I was compared to Django and Charlie Christian. I was friends with Les Paul; he was quite a character. The nightclubs were packed with people until 4:30 in the morning.

I had the world on a string.

—Joe Cinderella, jazz guitarist

# ACKNOWLEDGMENTS

I wish to thank the Library of Congress for allowing me access to the William P. Gottlieb Collection of photographs. As I was working on my research, I was surprised to find that William Gottlieb grew up in Bound Brook, one town away from my hometown. Without the William Gottlieb photographs, a large chunk of history would be gone forever, and I am grateful for his amazing photographs that capture the most beautiful, fascinating, and elegant time in jazz on Fifty-second Street. Unless otherwise noted, images come from the William Gottlieb Collection.

I would like to thank Steve Lucas, guitarist with the Les Paul trio, for introducing me to legendary guitarist Joe Cinderella. A monster guitar player compared to Charlie Christian and Django Reinhardt, inventor of the eight-string guitar, guitar player of the year, and guitarist on the Blue Note and Prestige record labels, Joe Cinderella was probably the last living legend of Fifty-second Street.

I met Joe this past October. I had my custom Johnny Smith guitar and could not wait to jam with him. The first thing Joe Cinderella said to me was how he played with Johnny Smith at Birdland. "Elizabeth, Johnny Smith was fabulous, flawless, fast, and had great technique," said Joe Cinderella. He went on to say, "I knew everybody on Fifty-second Street, and I played with all of the legends. Charlie Parker loved the way I played and considered me one of his favorite guitarists. He would sit at the front of the stage and watch me play." "Billie Holiday was a sweet lady and we met a few times at Birdland. She was quiet, and lovely, and Sara Vaughn was much more outgoing. Some of my favorite players that I worked with are Les Paul, Donald Byrd, Zoot Simms, Oscar Pettiford, Judy Garland, Gil Melle, and Bill Evans. Bill Evans was my favorite piano player and I really loved his style. He looked like a movie star," stated Cinderella.

We played the guitar on "Lush Life," a song he recorded with bassist Vinnie Burke and Chris Conners, marking the beginning of vocal/guitar jazz style. Joe Cinderella gave me his custom-made eight-string Mottola guitar, and he played my Johnny Smith. We also played "All of Me," "Green Dolphin Street," "Lover Man," "Nica's Dream," and "Donna Lee." We talked about forming a duet; however, as fate would have it, Joe passed a week later, and I was the last person to play guitar with this guitar great.

I would like to thank Jimmy Leahey for the wonderful pictures of guitarist Harry Leahey. A thank-you is owed to Phil Woods, my former guitar teacher and musical mentor.

A sincere note of thanks to Joseph Kinney, manager of the New Yorker Hotel, for allowing me access to his exquisite collection of photographs along with a grand tour of the hotel, the Hammerstein Ballroom, the hidden tunnel to Pennsylvania Station, and the famous room of inventor Nikola Tesla.

I would like to thank Frank Mulvaney, president of the New Jersey Jazz Society, and his wife, Kathy, for allowing me into their house to access their amazing collection of jazz artists.

I would like to thank the Plainfield Historical Society, especially Naney Piwowar, Anita Rifino, and Elizabeth Rifino.

# INTRODUCTION

It was as if all of the stars in the universe lined up on Fifty-second Street in New York City in 1947 and shimmered a little brighter, fueled by hot jazz, perfume, sophisticated ladies, hipsters, powder and perfume, high heels, couples dancing, gardenias, and pinstripe suites. This hot and spicy gumbo, flavored with the essence of elegance and swagger, was the beating heart of New York City jazz, and it was on fire in the historic brownstones on West Fifty-second Street. For just a short while, an elusive spell was cast on "Swing Street" but then vanished into stardust. The nightclubs, such as Aquarium, Spotlite Club, Downbeat, Three Deuces, Onyx, Stork, Vogue, Jimmy Ryan's, and the Hickory House, took center stage. The glittering neon signs were like magnets, pulling in the most prominent jazz musicians to play. Swing Street was a concrete playground for the rich and famous, movie stars, songwriters, dancers, mobsters, intellectuals, and even the average folk. Every famous jazz musician performed here.

The exterior of the many haunts, hideaways, and nightclubs were aglow with their luminous neon signs. These hangouts were located between the East River and the shipyards along the Hudson River. Often, one would feel the warm breath of the gray waters while taking in the faint sounds of a hot jam, including a piano, Latin percussion, horns, and a gypsy guitar, expressing the spirit of this town. Barhopping went all night and would often meet the rising sun. The Vogue Room, Spotlite, Onyx, Latin Quarter, Apollo Theater, Minton's Playhouse, Stork Club, Birdland, and Copacabana were just a few of the hot spots of the day. This lively scene was full of hipsters, sophisticated ladies, and great jazz players and singers of that era. New York City, since the dawn of the 20th century, has been the jazz capital of the world, with Dixieland and ragtime in the early 1910s; swing and big band in the 1930s–1940s; bebop in the mid-1940s; Latin jazz, Afro-Cuban, and Brazilian jazz in the 1950s–1960s; folk and rock and roll and rock-influenced jazz in the late 1970s; fusion, acid jazz, and funk in the 1980s; and present-day R&B and hip-hop. It has been a long time now, and not many remember the swagger on Fifty-second Street. However, those who remember can still get lost in memories of gypsy jazz guitars and saxophones wailing on starry nights and feel the mysterious spell that was cast. Moonbeams and stars flickered until the last morning star faded around 4:30 a.m., giving some guiding light to late-night laughter and romance. This elusive spell of jazz evaporated as if it almost never existed. In an instant, after World War II ended, the world was changed forever, and all the stars that shined so brightly on this lively New York City jazz scene of this era faded into stardust.

New York City nightclubs started as Harlem rent parties, where live jazz bands played all night to a festive crowd in small apartments, making just enough money to pay for another month's rent. Harlem rent parties were in vogue and soon blossomed into the uptown nightclub scene, making huge names for the Apollo Theater, Cotton Club, and Minton's Playhouse. The glitzy and extravagant live-music shows attracted everyone from New York high society to the regular guy working on the shipping docks. The theme of these early jazz shows included stages that were decorated to mirror Southern antebellum plantations with tall white columns and live oaks

draped in Spanish moss. Soon, the jazz scene was moving downtown to Fifty-second Street, where a vibrant new jazz scene was emerging. It would be the first time that white and black patrons and musicians were accepted into the same clubs as equals and allowed to share the same stage.

This new music scene was on fire with the introduction of the electric guitar by Charlie Christian and Les Paul. The electric guitar took center stage with the help of Les Paul, Charlie Christian, Wes Montgomery, Django Reinhardt, and Freddie Green. Nat King Cole developed the first trio, and small-combo jazz quartets were replacing the swing and big band orchestras. Musicians like Charlie Parker, Miles Davis, John Coltrane, Thelonious Monk, Bill Evans, Dizzy Gillespie, and Lester Young were exploring the harmonic boundaries of improvisation, which led to the birth of bebop. Each of these artists left an impression on the jazz world. There will never be a more fascinating, elegant, or magical place as New York City jazz in its golden era.

*New York City Jazz* will utilize exquisite photographs to tell the story of the golden era of jazz. This book will give the reader a timeline that will show how jazz was shaped and how this music is still influencing Broadway, rock and roll, blues, R&B, and hip-hop. Music is an elusive force that connects us all—from the people of yesterday to today.

As an up-and-coming guitarist, I, the author, hope this book helps people realize that the building blocks for the future of music are built upon the cornerstones of the past. I believe the people mentioned herewith in have the power to inspire a new generation of musicians, poets, peacemakers, and creative souls.

# One

# THE NIGHTCLUBS
# AND BEBOP

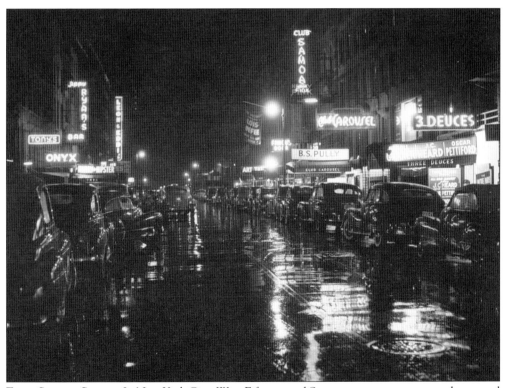

FIFTY-SECOND STREET. In New York City, West Fifty-second Street was once a concrete playground for the rich and famous who swarmed into these two blocks of brownstones to hear the finest musicians in the world play. Swing Street was home to movie stars, songwriters, dancers, and the hardworking guy trying to impress his date. These two blocks of nightclubs on West Fifty-second Street, between Fifth and Seventh Avenues, had a combination of elegance and swagger, attracting people from everywhere. Some of famous nightclubs, haunts, and hideaways on Fifty-second Street included the Aquarium, Spotlite Club, Downbeat, Stork Club, Three Dueces, Hickory House, and Onyx Club.

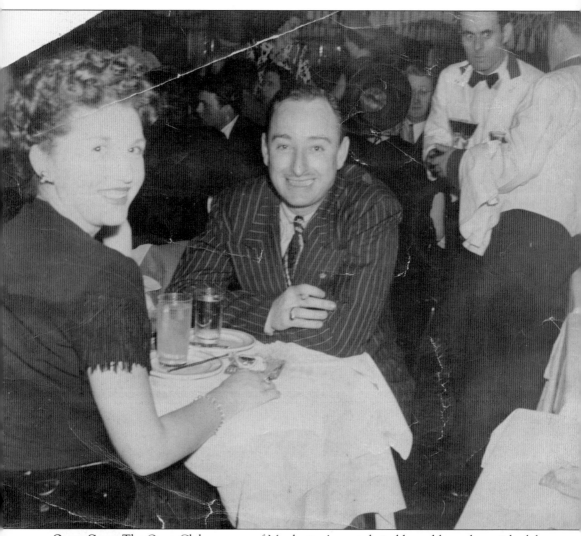

**ONYX CLUB.** The Onyx Club was one of Manhattan's most desirable and legendary nightclubs on 62 West Fifty-second Street. It was the place that offered unforgettable experiences. With the romantic ambience of the Fifty-second Street scene, songwriter Richard "Dick" Dodd of Jersey City fell in love with Elizabeth "Betty" Parowski, a Bayonne, New Jersey, native. This is a picture of the recently engaged Betty and Dick at their favorite haunt, the Onyx Club. The Onyx was the place to go for the ultimate indulgence, bursting with famous jazz musicians. The timeless style of classic New York City in 1947 could be found at the Onyx Club. (Author's collection.)

NEW YORK CITY'S SKYSCRAPERS. New York's famous skyline, with its larger-than-life skyscrapers, evokes a feeling that all dreams are possible here. Its inspiration may have led to the creation of the largest amount of jazz standards, show tunes, and Broadway plays ever written. The New Yorker Hotel (pictured), built in 1928, was Art Deco style, like its contemporaries the Empire State and the Chrysler Buildings, and cost $22.5 million. (Courtesy of Joseph Kinney.)

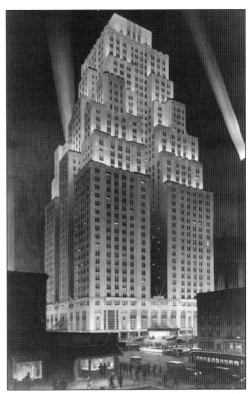

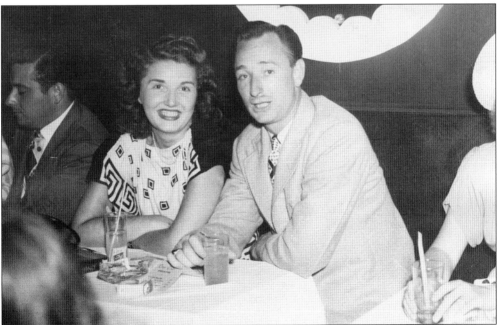

JUST ENGAGED! Songwriter Richard Dodd and Elizabeth Parowski are having dinner at the Stork Club, located on 3 Fifty-second Street, to celebrate their engagement. Dick proposed to Betty at the Stork Club. Betty and Dick met at the naval base in Bayonne, New Jersey. Richard was working as a military police officer, and Elizabeth was the manager of the shipyard. (Author's collection.)

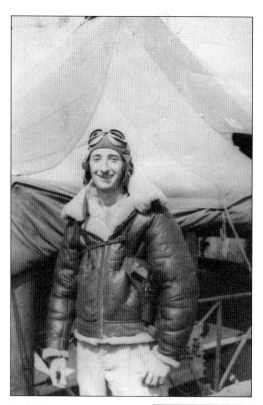

**SOLDIER BOY.** On December 7, 1941, America entered World War II, and Richard Dodd, pictured here in the deepwater facility of Port Moresby, New Guinea, enlisted in the Pacific theater. Lieutenant Dodd joined the brotherhood of thousands of working jazz musicians from New York City and musicians from around the country who enlisted in World War II. This changed the landscape of jazz forever. With many accomplished jazz musicians going to war, the large number of musicians needed for big band and swing jazz was not met, and so that style of jazz was replaced by jazz trios and quartets, which became the cornerstone of bebop. (Author's collection.)

**CHARLIE'S TAVERN.** In the mid-1940s, jazz started moving north of Harlem to Fifty-second Street, where it morphed into a vibrant scene with a new unique flavor. Small-combo jazz and jazz trios were replacing the big band and swing orchestras, and the emergence of bebop was taking center stage.

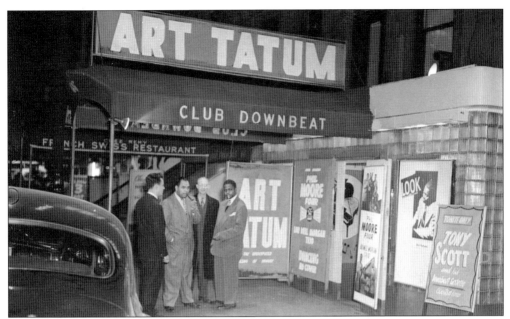

**CLUB DOWNBEAT.** Here, Art Tatum (far right) and Phil Moore (second from the left) are standing in the front of the Club Downbeat on 66 West Fifty-second Street in 1948. The Downbeat was the most-famous club at this time, and jazz legends Miles Davis, Harry Gibson, Dizzy Gillespie, Ella Fitzgerald, Billie Holiday, and Thelonious Monk graced its stage. Cocktail waitress Helen Noga, along with her husband, John Noga, owned the Downbeat.

**DIZZY GILLESPIE, FIFTY-SECOND STREET, 1946.** In between sets at a gig at the Downbeat, Dizzy Gillespie is seen here standing on Fifty-second Street. Dizzy was one of the most influential trumpet players in jazz. As a trumpet player, singer, composer, and bandleader, he is considered a key player in the development of bebop and modern jazz, along with Thelonious Monk and Charlie Parker. After spending time in Cuba in the 1940s, he introduced Afro-Cuban jazz to the sounds of big, band, swing, and traditional jazz.

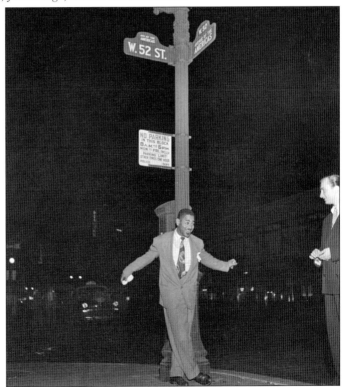

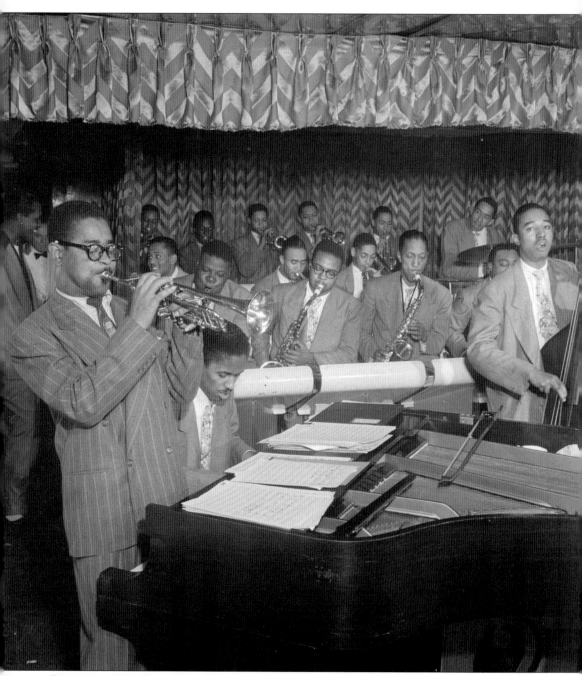

**DOWNBEAT, NEW YORK, NEW YORK, AUGUST 1947.** In this photograph, from left to right, Dizzy Gillespie, pianist John Lewis, saxophonist Cecil Payne (immediately behind Lewis), and bassist Ray Brown are playing at the Downbeat on West Fifty-second Street. This was the hottest venue at this time in New York City. This was an extraordinary time in jazz with the birth of bebop, and each of these players would become legends. Cecil Payne played baritone saxophone, and his most memorable work was with Dizzy Gillespie and Kenny Burrell on Prestige Records. Ray Brown was also the bassist in the Duke Ellington Band.

**CLUB ONYX, FIFTY-SECOND STREET.** This July 1947 picture shows Wilbur De Paris standing in front of the Onyx. At this time, Wilbur and his brother Sidney De Paris's band, New Orleans Jazz, was one of the most popular bands playing on Fifty-second Street. The band included legendary pianist Jelly Roll Morton, drummer Zutty Singleton, and Freddie Moore on guitar. New Orleans Jazz was known for blending New Orleans jazz music with New York swing.

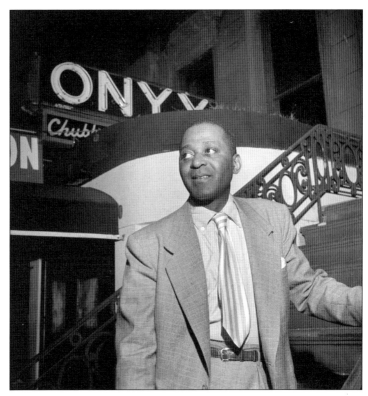

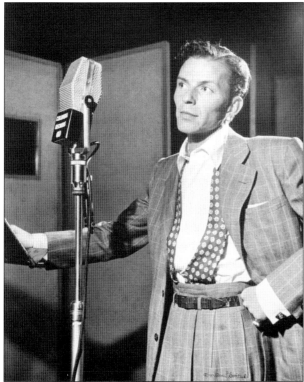

**FRANK SINATRA, NEW YORK, NEW YORK, 1947.** After leaving Tommy Dorsey and his orchestra, Frank Sinatra started looking for jobs as a singer. Initially, he was unable to find a serious gig, and he played briefly with the Harry James's band. In December 1942, things changed when he took a New Year's Eve job with Benny Goodman in the Paramount Theatre, and a star was born. "Ole Blue Eyes" would become one of the most famous entertainers in the world and also a member of the infamous Rat Pack in Hollywood.

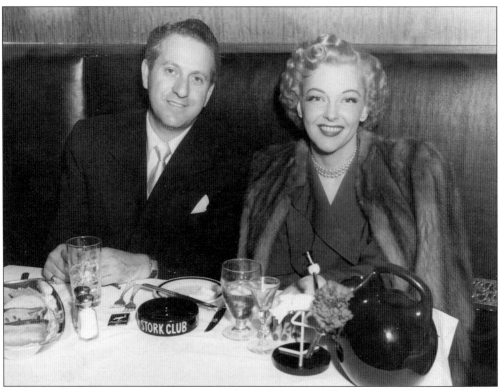

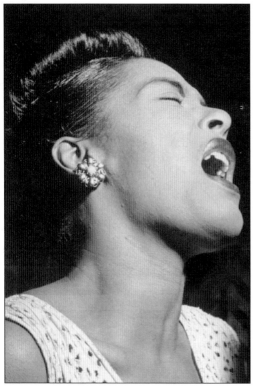

**THE STORK CLUB.** Vivian Blaine and her agent and husband, Manny Frank, are at the Stork Club at 3 Fifty-third Street. The Stork Club mixed swagger, power, money, and glamour. The building was demolished in 1966 and is now Paley Park. The Stork Club, also known as "the snub room," was guarded by "Saint Peter," as in the gates of heaven. Famous illustrators such as E.C. Seger (Popeye), Chic Young (Blondie), and Theodor Geisel (Dr. Seuss) hung out here. Owner Sherman Billingsley was known for his extravagant gifts, like compacts studded with diamonds and rubies, champagne, and automobiles. (Author's collection.)

**BILLIE HOLIDAY.** This iconic picture shows Billie Holiday singing at the Club Downbeat on Fifty-second Street. At the time this photograph was taken, Billie was the peak of her career. Billie Holiday's set consisted of "Lover Man" and "Swing Brother Swing." Lady Day was the most exceptional singer of her era due to her unique new style and her ability to incorporate new ways of phrasing and tempo with a mellow intensity.

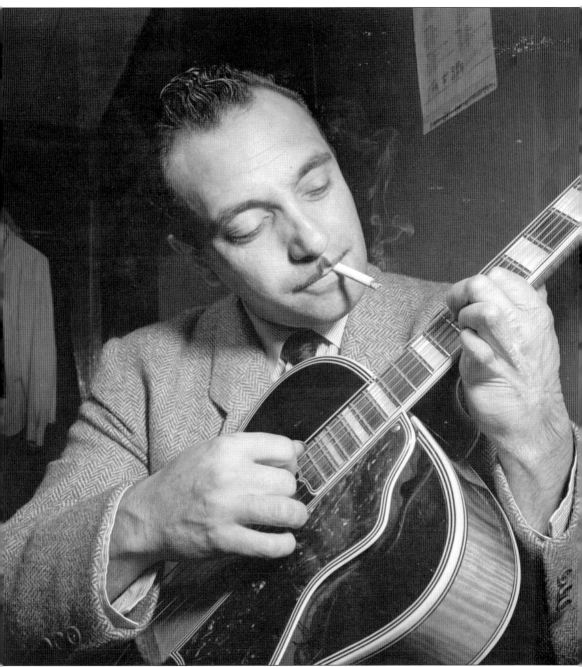

**DJANGO REINHARDT, AQUARIUM, 1946.** Django Reinhardt was an amazing gypsy jazz guitarist and composer and is ranked as one of the greatest guitar players of all time. Reinhardt introduced a new style of jazz guitar technique called hot jazz or gypsy guitar. He cofounded the Quintette du Hot Club de France with violinist Stéphane Grappelli. Django Reinhardt's most popular songs have become jazz standards, including "Minor Swing," "Daphne," and "Nuages." His fingers were badly burned when the tent he was living in caught on fire, causing him to switch from playing violin to guitar.

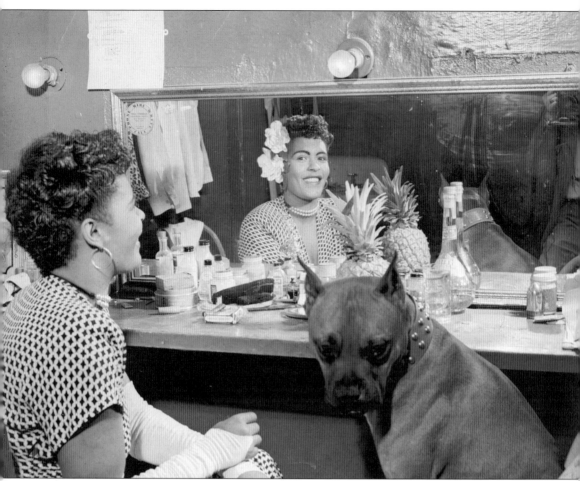

**BILLIE HOLIDAY IN HER DRESSING ROOM OF THE CLUB DOWNBEAT.** Billie Holiday always brought her dog Mister along with her to gigs; the boxer waited patiently in her dressing room. On stage, Billie Holiday was one of the most innovative and unique jazz singers. She was always behind the beat, with her right hand keeping time with the drummer; her voice shimmered like diamonds on a moonlit sea. Billie Holiday's vocal style took on an intimate approach. The instruments playing behind her inspired her phrasing and rich melodic tone.

HOWARD MCGHEE AND
MILES DAVIS, NEW YORK, C.
SEPTEMBER 1947. This is a
picture of Howard McGhee
(right), Miles Davis (center),
and an unidentified man. Miles
Davis was a child prodigy who
mastered the trumpet at a
very young age. The son of a
successful dentist, Miles Davis
grew up in Illinois, and at 18, he
moved to Manhattan after being
accepted into the prestigious
Julliard Music School. He
was quickly playing high-end
gigs with Charlie Parker and
Dizzy Gillespie; they started
experimenting with cool jazz and
modal jazz and began pioneering
the bebop movement. Miles
Davis, along with Bill Evans,
recorded the album *Kind of Blue*,
which was revolutionary at the
time because of its modal sound;
it is still the number one–selling
jazz album of all time.

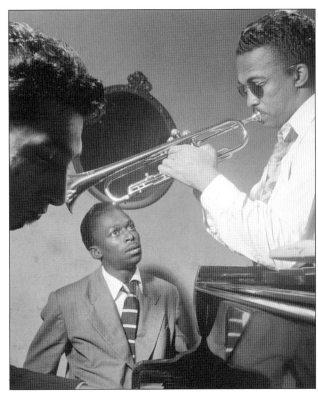

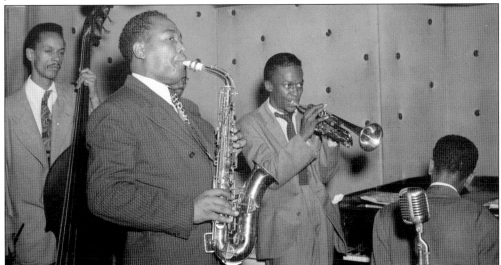

SAXOPHONIST PARKER, BASSIST POTTER, TRUMPETER DAVIS, PIANIST "DUKE" JORDAN, AND DRUMMER
ROACH, AUGUST 1947. Charlie "Yardbird" Parker was one of the greatest saxophone players of all
time but struggled with addiction throughout his short career that was shortened by his untimely
death at 34 years old. In this photograph, Parker has just returned from California and rehab, and the
Three Deuces has booked him and his band on his first night back on Fifty-second Street. Charlie
Parker was equally popular in France, where he was the toast of Paris. Parker married Doris Snyder,
his third wife, in 1948 but started living with Chan Richardson in 1950, and they had two children.
Chan and Charlie never married, but Chan would marry Phil Woods after Charlie's death.

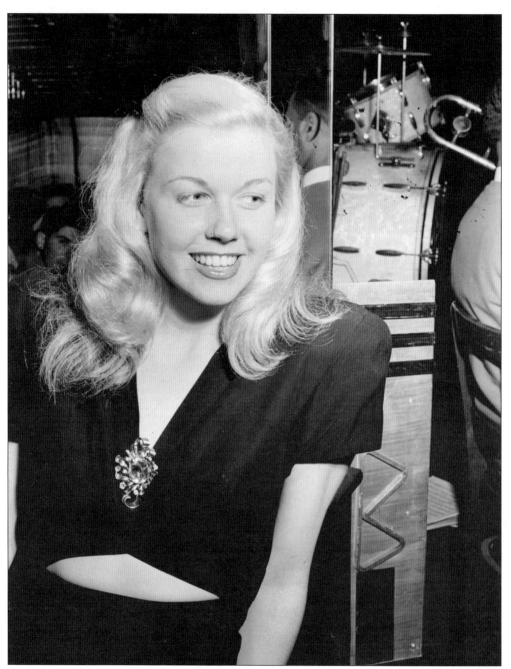

**DORIS DAY, AQUARIUM, JULY 1946.** This is a picture of Doris Day singing at the Aquarium in New York City. Doris Day first started singing with big bands and swing bands between 1939 and 1945. Some of the famous bandleaders that she sang with include Les Brown, Tommy Dorsey, Glenn Miller, and Artie Shaw. Her major breakthrough came after her recording of "Sentimental Journey," which became a huge hit. This soon attracted the executives at Columbia Records, where she signed a lucrative contract that lasted for 20 years and produced over 650 recordings. Doris Day was also a successful Hollywood actress and highlights include *Romance on the High Seas* and *The Ghost and Mrs. Muir*, making her one of the highest-paid entertainers in the world.

COLEMAN HAWKINS AND MILES
DAVIS, THREE DEUCES, JULY
1947. In this photograph at the
Three Deuces, Coleman Hawkins
and Miles Davis are performing
during the summer of 1947.
Coleman "Hawk" Hawkins was
known for his major innovations
on the tenor saxophone in
swing and big band music and
impressed everyone with his
beautiful tone. He was also a
major player in the development
of bebop. He influenced John
Coltrane, Sonny Rollins, Dexter
Gordon, and many other great
players. He set the bar very
high with his complex lines
and beautiful tonality. His
interpretation of the song "Body
and Soul" was so pretty that it
became his signature song.

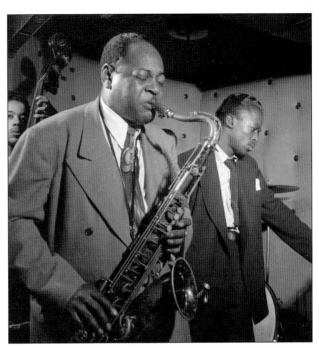

LENA HORNE, NEW YORK, NEW YORK, 1947. Lena Horne started her career in the chorus of the
Cotton Club, located around the corner from the apartment that she grew up in. She was very
influenced by Billie Holiday, and they would later become friends and often sang at the same
nightclubs. She soon moved to Hollywood, where she was hired for small roles in the films *Cabin
in the Sky* and *Stormy Weather*. Her controversial political views helped to influence her decision to
move back to New York City. There, Lena continued to work as a singer in nightclubs, Broadway,
radio, and television and released a succession of successful jazz albums.

**BETTY GEORGE, COPACABANA, 1946.**
This is a picture of Betty George at the Copacabana. Betty George was a ballad singer who also sang big band and swing styles with Glenn Miller, Tommy Dorsey, and Artie Shaw. She recorded for CBS Studios and Decca Records. The Copacabana was in vogue at this time with exotic Brazilian decor, Latin-themed music, and a menu that served Chinese food. The club was also known for its chorus line of Copacabana Girls, who had elaborate sequined costumes, fruited turbans, and glittering headpieces with jewels and feathers. It was a combination of vaudeville, burlesque, and Latin-influenced jazz.

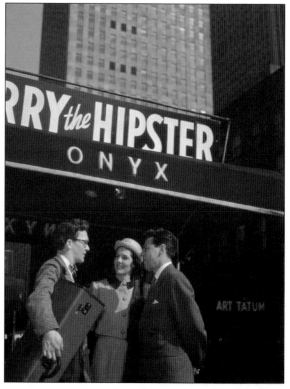

**TOOTS THIELEMANS, ADELE GIRARD, AND JOE MARSALA, ONYX, 1946.**
It was late at night when this street really came alive with all the colorful neon signs and loud jazz music spilling out from the clubs. This picture captures the swagger on Fifty-second Street. Toots Thielemans (left) is a guitar player who got his big break in an after-hours jam session with Charlie Parker, Miles Davis, Max Roach, and Sidney Bechet at the Spotlite Club. His career highlights include being a member of Charlie Parker's All Stars and recordings and live gigs with Miles Davis and Dinah Washington. Adele Girard auditioned for the role of Scarlett O'Hara in the movie *Gone With the Wind*.

**LES PAUL.** Les Paul was a legendary jazz guitarist, songwriter, and inventor. Les Paul got his big break as a last-minute replacement for Oscar Moore and was then hired by Nat King Cole. His guitars are synonymous with the Gibson brand, an endorser of his invention of the solid-body electric guitar. His guitar also made the sound of rock and roll explode. He had a successful career with his wife, Mary Ford, and they had many hit songs, including "How High the Moon." He has one son, Rusty Paul, who is an amazing bass player who performs in the top clubs in New York City with legendary guitarist Steve Lucas.

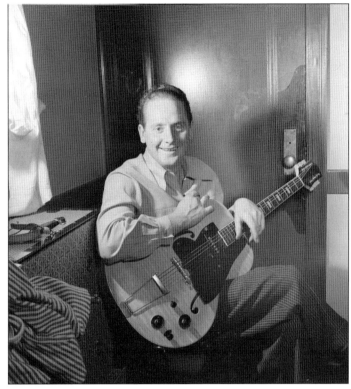

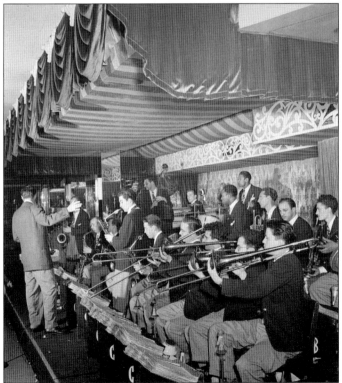

**CHARLIE BARNET WITH THE AQUARIUM ORCHESTRA, FIFTY-SECOND STREET, 1947.** The Aquarium was one of the first successful nightclubs to open in this section of Manhattan. Charlie Barnet was the grandson of Charles Frederick Daly, who was the vice president for the New York Central Railroad. He came from a successful and wealthy family of bankers and executives. Charlie Barnet was born in New York City and would often cut classes to hang out in the hot jazz clubs and listen to music, which would change his destiny.

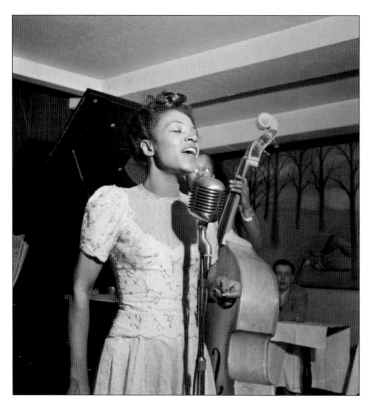

**MAXINE SULLIVAN, AQUARIUM, 1943.** Pictured is singer Maxine Sullivan at the Aquarium on Fifty-second Street. Maxine Sullivan first started singing in the band Red Hot Peppers, where her uncle was the bandleader. After leaving Pennsylvania, Maxine Sullivan moved to New York and had steady work as the featured vocalist at the Onyx Club. While singing at the Onyx, she often played with the bass player John Kirby, and they fell in love and married. Maxine Sullivan had a career that spanned almost 50 years.

**THREE DEUCES.** Hanging out at the Three Deuces club on Fifty-second Street was often compared to being in a candied heaven, with jazz being the sweet and tasty candy. It was a place where one could watch Coleman Hawkins, Lester Young, and Billie Holiday until the sun came up and then walk away with money still in the wallet. The Three Deuces had some of the best musicians in the world perform there. The signature trademark of the Three Deuces was three deuces from a deck of cards. The Three Deuces was a club that promoted new and young talent with an emphasis on jazz trios and quartets.

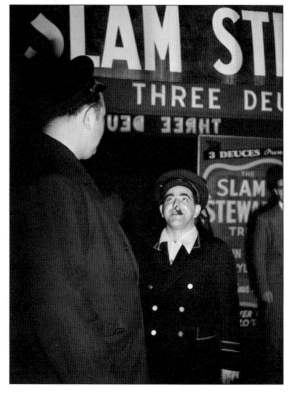

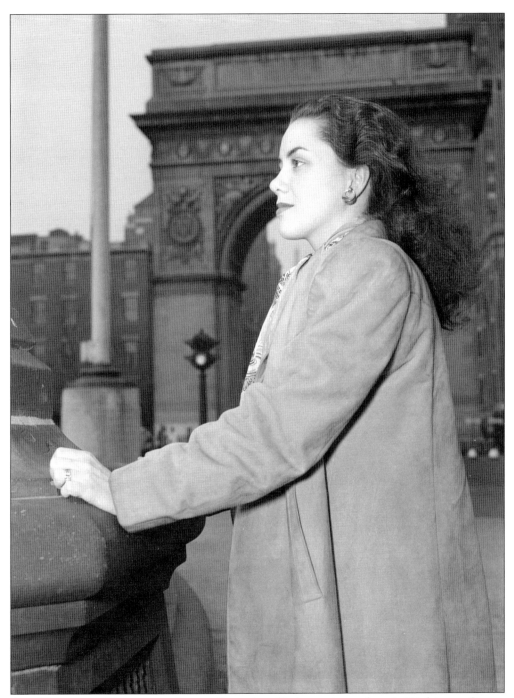

**ANN HATHAWAY, WASHINGTON SQUARE PARK.** Ann Hathaway is seen here in Washington Square Park. She was an excellent vocalist who was very under rated. She could sing ballads, swing, and popular tunes and made a lot of recordings with Capitol and Decca record labels. Washington Square Park was once farmland before the Dutch gave the land to free slaves. It was a favorite hangout for musicians and poets. Today, it is a vibrant New York City landmark that still attracts musicians, poets, and artists to come together as a community.

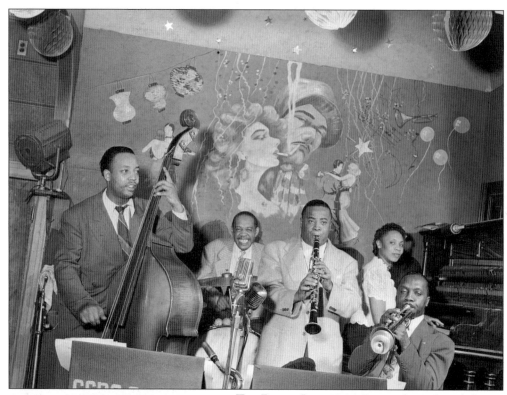

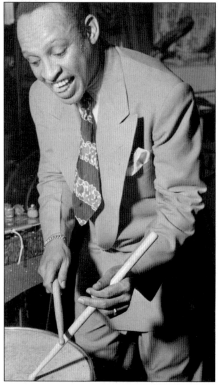

**THE PLACE, JULY 1946.** Pictured are, from left to right, Danny Settle, Slick Jones, Gene Sedric, Mary Lou Williams, and Lincoln Mills. Mary Lou Williams was the only female musician that spearheaded the bebop movement alongside Miles Davis, Thelonious Monk, Dizzy Gillespie, Coleman Hawkins, and others. She recorded over 100 songs and wrote hundreds of arrangements for Duke Ellington, Billy Strayhorn, Billy Eckstine, and Benny Goodman. She was an accomplished piano player and singer. She had a steady gig at the Café Society and her own WNEW radio show, *Mary Lou Williams's Piano Workshop*, and would mentor the top players in the emerging bebop movement.

**LIONEL HAMPTON PLAYING AT THE ZANZIBAR CAFÉ IN NEW YORK.** Lionel Hampton was a multitalented bandleader and musician who played the vibraphones, piano, and percussions. Hampton, along with Red Norvo, was one of jazz's first vibraphone players to make this instrument a vital part of jazz. Hampton worked with just about everybody in the jazz scene. He is pictured here at the Zanzibar nightclub, which was one of the most prestigious high-end bars that served the finest jazz and cocktails.

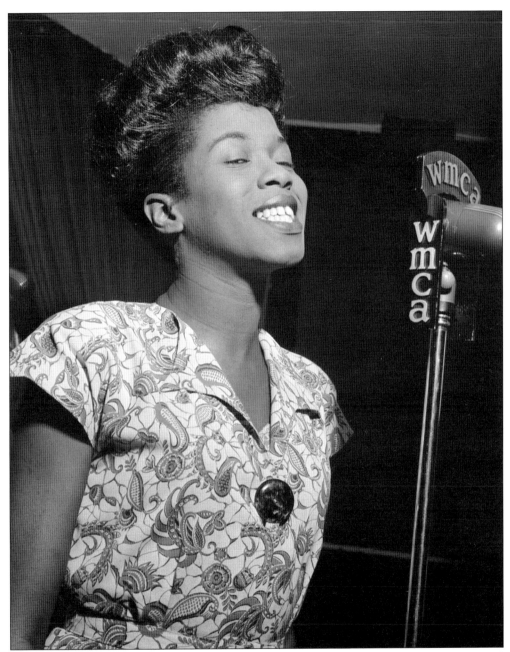

**SARAH VAUGHAN, CAFÉ SOCIETY DOWNTOWN, SEPTEMBER 1946.** Sarah Vaughan's stars all started to line up as she began her solo career in 1945 by freelancing in clubs on Fifty-second Street. Sarah Vaughan recorded "Lover Man" for the Guild record label with a quintet that featured Dizzy Gillespie, Charlie Parker, Al Haig, Curly Russell, and Sid Catlett. Sarah Vaughan worked with trumpeter George Treadwell, and the two fell in love and married and built a beautiful mansion in Newark, New Jersey. George Treadwell became her manager and reinvented her. She was transformed into a glamorous singer with beautiful sequined gowns, exquisite hairstyles, and cosmetic dentistry which helped her to skyrocket to the top of the music scene. Highlights include her hits "Deep Purple" and "Tenderly." She is recognized as one of the greatest singers of all time.

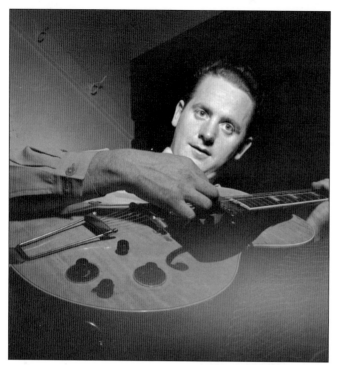

LES PAUL. Les Paul was the most instrumental electric guitarist and inventor in the development of the electric solid-body guitar. In addition to being a brilliant guitarist, he was also an inventor and almost electrocuted himself while working on his electric guitar inventions. Les Paul built the first solid-body electric guitar in 1941 and continued to make improvements on it for decades. He has influenced almost every great electric guitar player who has ever picked up the guitar, and his legendary Les Paul guitar is still the top-selling guitar of all time. The Les Paul guitar helped to produce the signature sound of Jimmy Page of Led Zeppelin.

THELONIOUS MONK AND HOWARD MCGHEE, MINTON'S PLAYHOUSE, SEPTEMBER 1947. This is a picture of Thelonious Monk (left) who is considered to be one of the most important musicians in the development of bebop music. He was an accomplished pianist and composer who was able to dig deep inside of his soul to create both complex and dissonant harmonies in his compositions while blending them with other styles of jazz. He was often very eccentric, and his signature style included sunglasses, wild hats, custom-made suits in all different colors, and lots of bling. He worked with Mary Lou Williams to carve out a new path in jazz that included unique improvisational lines, percussive interpretations, and elements of classical, modal, cool jazz, Latin, and Afro-Cuban music.

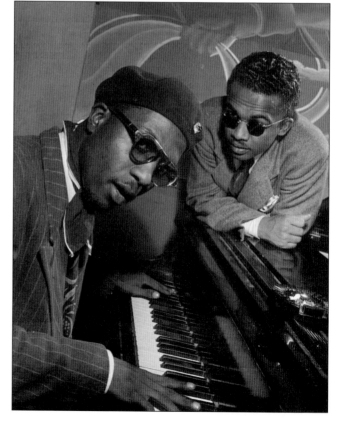

CHARLIE CHRISTIAN (JULY 29, 1916–
MARCH 2, 1942). Charlie Christian
was an amazing single-note jazz and
swing guitarist from Oklahoma City.
He was one of the most instrumental
musicians in introducing the
electric guitar and played a minor
role in the development of bebop and
cool jazz. His single-string technique
combined with an amplifier helped
turn the guitar into a solo instrument.
He was discovered by Benny
Goodman while taking a solo on the
song "Rose Room" and was hired on
the spot. He remained in the Benny
Goodman Sextet from August 1939
to the summer of 1941. He was the
best improvisational guitarist of the
swing era. His short life of 26 years
is credited as the inspiration for such
monster guitarists as Jimi Hendrix,
Eric Clapton, Wes Montgomery, Joe
Satriani, Pat Methany, Larry Coryell,
and Pat Martino. He will continue
to inspire the next generations of hot
guitarists. (Author's photograph.)

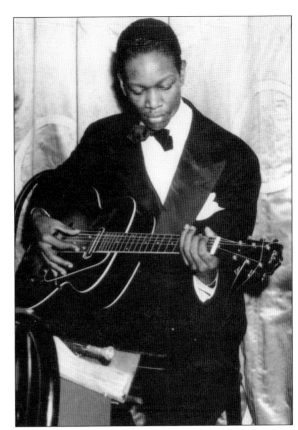

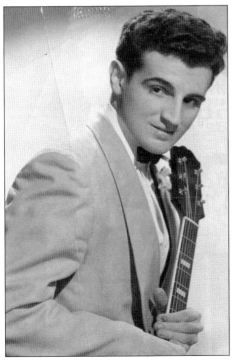

JOE CINDERELLA, BIRDLAND. Joe Cinderella
was one of the greatest guitar players of all
time. He played at the Birdland jazz club for
over 30 years. Charlie Parker loved the way
Joe Cinderella played the guitar and would
sit in the front row at Birdland and watch
Joe play. Cinderella invented the eight-string
guitar, wrote two music books, and recorded
with Blue Note Records and Prestige Records.
Joe Cinderella's signature sound was a rarity
and no one has been able to come close to his
expertise, single lines, chordal harmonies, tone,
speed, and accuracy. (Courtesy of Steve Lucas.)

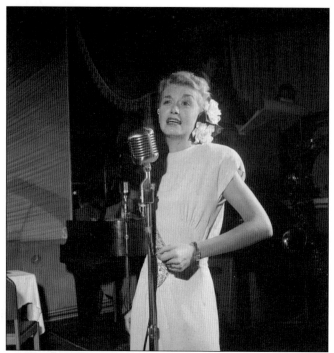

**JUNE CHRISTY.** June Christy worked as a singer on Fifty-second Street and performed with many big bands and swing bands, including Tommy Dorsey and Artie Shaw. Her big break came when she replaced Anita O'Day in the Stan Kenton Orchestra. She had a unique voice and liked to experiment with cool jazz. She was very popular, and some of her top hit songs included "How High the Moon" and "Tampico."

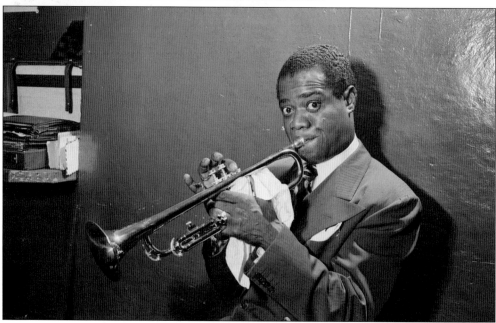

**LOUIS ARMSTRONG AT CAFÉ SOCIETY, 1946.** Louis "Satchmo" Armstrong had a successful jazz career in New Orleans before coming to New York City. He is probably the most important person in the history of jazz. Armstrong could play any style, including Dixieland, ragtime, big band, swing, and blues. He formed the successful six-piece group Louis Armstrong and his All Stars, which included Jack Teagarden and Earl Hines. He was the recipient of the Grammy Lifetime Achievement Award. The Louis Armstrong Museum in Queens, New York, showcases all of his contributions to jazz.

**JEANNE CUMMINS.** This stunning picture of Jeanne Cummins with the Bernie Cummins Orchestra is hanging in the lobby of the New Yorker Hotel. Jeanne started singing in Ohio and sang in Las Vegas for a year with Bernie Cummins's band. She married Walter Cummins, who was the guitarist for the Bernie Cummins Orchestra, and they had five children and own a successful chain of bakeries in Ohio. Her career also included a screen test in Hollywood and many radio and television shows in Ohio. (Courtesy of the Walter and Jeanne Cummins's Children Collection.)

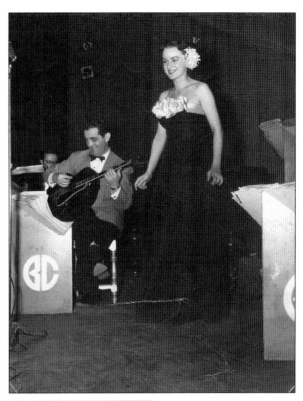

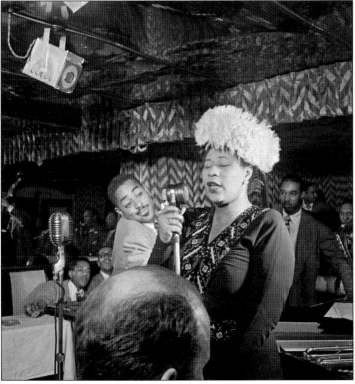

**ELLA FITZGERALD AND DIZZY GILLESPIE, DOWNBEAT, SEPTEMBER 1947.** This is a photograph of Ella Fitzgerald, with Dizzy Gillespie looking over her shoulder, at the Downbeat. Ella Fitzgerald was known to be extremely shy, and when she was not singing on stage, she rarely hung out with other musicians. Many consider her to be the greatest jazz singer who ever lived, and she recorded over 700 songs with Decca Records, including "Summertime," "Cry Me a River," and "The Man I Love."

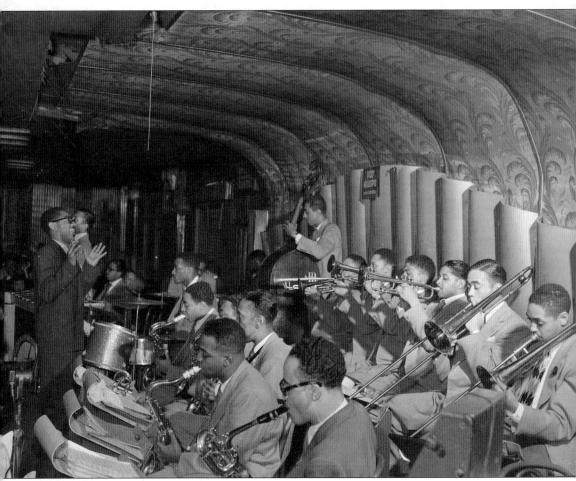

**DIZZY GILLESPIE AT THE CLUB DOWNBEAT, 1947.** This is a picture of Dizzy Gillespie as a bandleader at the famous Club Downbeat in 1947. He was one of the most brilliant trumpet players because of his superb skill, beautiful tone, virtuoso level, and complex improvisation. Dizzy Gillespie was heavily influenced by Roy Eldridge and was able to add more complexity to Roy's earlier style of playing. Dizzy also had a unique signature style of fashion and sometimes played solos on tabletops. He influenced many other great trumpet players, including Miles Davis, Clifford Brown, Fats Navarro, and Terrence Blanchard.

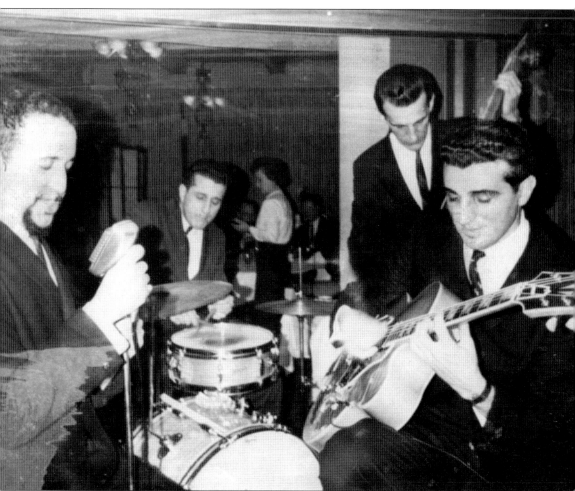

**Joe Cinderella at Birdland.** This is a picture of Joe Cinderella at Birdland getting ready for a show. He had the longest lasting career at Birdland—20 years! This legendary guitarist was a monster guitar player, compared to Charlie Christian and Django Reinhart. He was the inventor of the eight-string guitar, guitar player of the year, and guitarist on the Blue Note and Prestige Records labels. Joe Cinderella was probably the last living legend of Fifty-second Street and was friends with and played with Johnny Smith, Charlie Parker, Les Paul, Gil Melle, Vinnie Burke, Bill Evans, George Benson, Ella Fitzgerald, Dionne Warwick, and countless others. Elizabeth Dodd Brinkofski, the author, is honored to be the last guitarist to play such greats as "Donna Lee," "Lush Life," "On Green Dolphin Street," and "Nica's Dream" with Joe Cinderella in October 2012. "I felt like we were back on Fifty-second Street in the late 1940s," she stated. (Courtesy of Daria Cinderella and Joe Cinderella.)

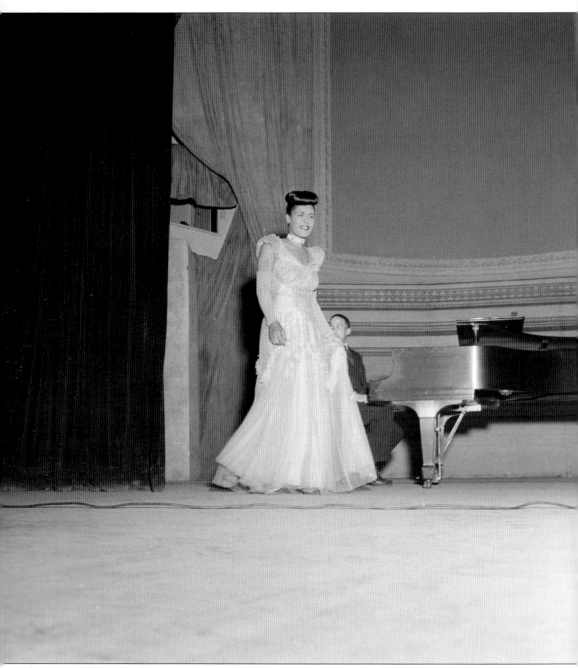

**BILLIE HOLIDAY, CARNEGIE HALL.** This is a picture of Billie Holiday walking on stage at Carnegie Hall, located on Seventh Avenue between West Fifty-sixth and West Fifty-seventh Streets, just south of Central Park. Carnegie Hall was built by millionaire philanthropist Andrew Carnegie in 1891 and is still the most prestigious music hall in the world. By 1947, Holiday was at her peak; however, she had a tragic personnel life that included heroin addiction, which overshadowed her musical achievements.

# Two

# THE ERA OF SWING AND BIG BANDS

**CHARLIE PARKER.** Charlie Parker was a highly innovative jazz soloist and a leading figure in the development of bebop. Bebop is different from the sounds of swing and big band because it has faster tempos and a more complex technique, features improvisation, and is harder to dance to. Charlie Parker was a virtuoso player who always found the "pretty notes" while blending complex harmonies, rapid passing chords, altered chords, and chord substitutions. His tone could reflect his mood, ranging from clean to sweet to somber. His recordings are timeless and reflect his virtuosic technique and influences of Latin, Afro-Cuban, blues, and classical. His remarkable style is studied at every great music college and university.

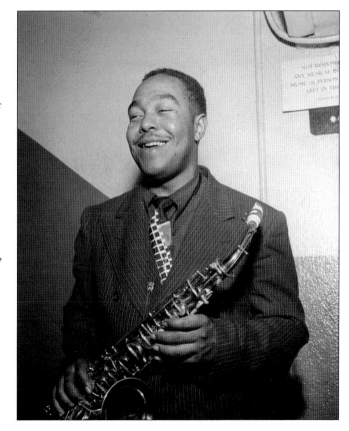

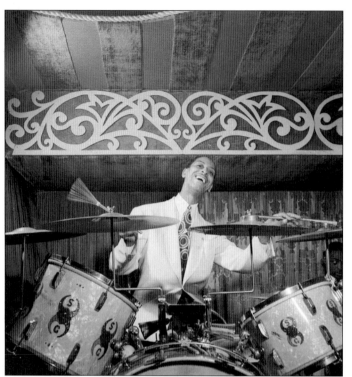

**SONNY GREER, AQUARIUM, c. NOVEMBER 1946.** Sonny Greer was from Long Branch, New Jersey, and was Duke Ellington's first drummer, playing with his quintet, the Washingtonians, at the Cotton Club. Greer had a huge and amazing drum kit as well as vibes, chimes, a timpani, and a gong. Sonny Greer's personal life was over shadowed by his heavy drinking and gambling, which led to his discharge from his prestigious touring gig with Duke Ellington. He would later have to sell his entire drum set to a pawnshop in Asbury Park, New Jersey, to pay off a gambling debt.

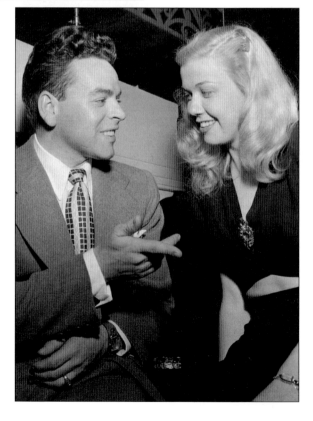

**DORIS DAY AND LES BROWN, AQUARIUM, JULY 1947.** Lester "Les" Brown was a musician, composer, and big band conductor who formed his own band, the Les Brown Band. One of his highlights was recording "Sentimental Journey" with Doris Day. The song would become a national anthem for returning soldiers coming home to their loved ones after World War II. Les Brown would continue to work in swing and big band jazz and was not a part of the new bebop movement. Doris Day would move on to become one of the most popular entertainers of all time.

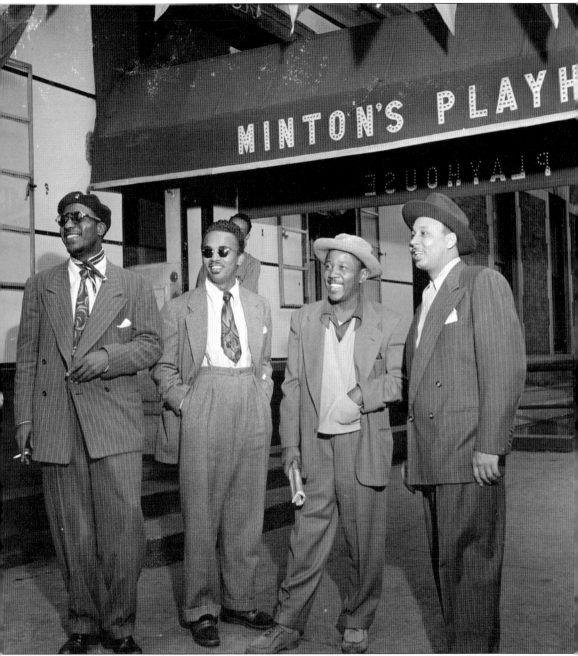

**THELONIOUS MONK, MINTON'S PLAYHOUSE, JULY 1947.** Thelonious Monk (left) was one of the most significant musicians to spearhead the bebop movement in New York City in the late 1940s. Bebop was the most important music change of this era. "I don't consider myself a musician who has achieved perfection and can't develop any further. But I compose my pieces with a formula that I created myself. Take a musician like John Coltrane. He is a perfect musician, who can give expression to all the possibilities of his instrument. But he seems to have difficulty expressing original ideas on it. That is why he keeps looking for ideas in exotic places. At least I don't have that problem, because, like I say, I find my inspiration in myself," said Thelonious Monk.

**STAN KENTON AND HIS ORCHESTRA ON THE ROAD.** Stan Kenton was a favorite at the Onyx, Downbeat, Aquarium, and Jimmy Ryan's. Stan Kenton had a different vision from the other musicians playing swing and big band. He liked to experiment with advanced harmonies and would often take his band on the road to attract new audiences. He had a string of original bands that blended traditional swing with cool jazz. It was not dance music, and so he was not popular with swing and big band purists. He called his new sound "progressive jazz," which was heavily influenced by Kai Winding, who was altering the sound of Kenton's horn sections with bongos and Latin rhythms.

**Tiny Grimes, Guitarist at the Downbeat, February 1947.** Tiny Grimes had a stellar guitar sound, good fortune, a grand style, and played with all of the greatest musicians on Fifty-second Street. When he arrived in New York, he started working with vocalist Billie Holiday. He made four recordings with his own group augmented with Charlie Parker, which are considered excellent examples of early bebop jazz. Some of his songs include, "Red Cross," "Romance Without Finance," and "I'll Always Love You Just The Same."

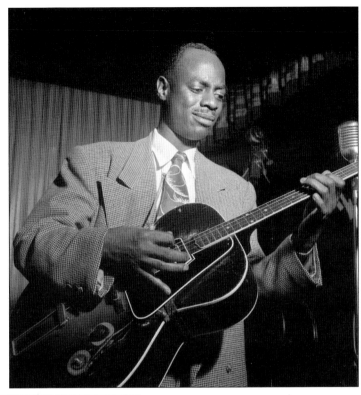

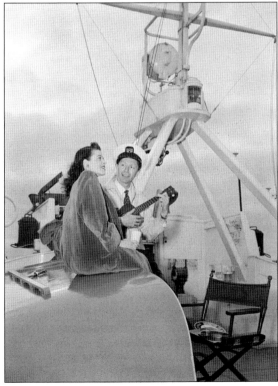

**Hudson River.** This is a picture of singer Betty Brewer on *Ukelele Lady* in June 1947. Brewer was a favorite at the Spotlite Club. Some of the famous orchestras that she sang with include Tommy Dorsey, Artie Shaw, and Glen Miller. At the time of this photograph, she had the hit song "Riders in the Sky."

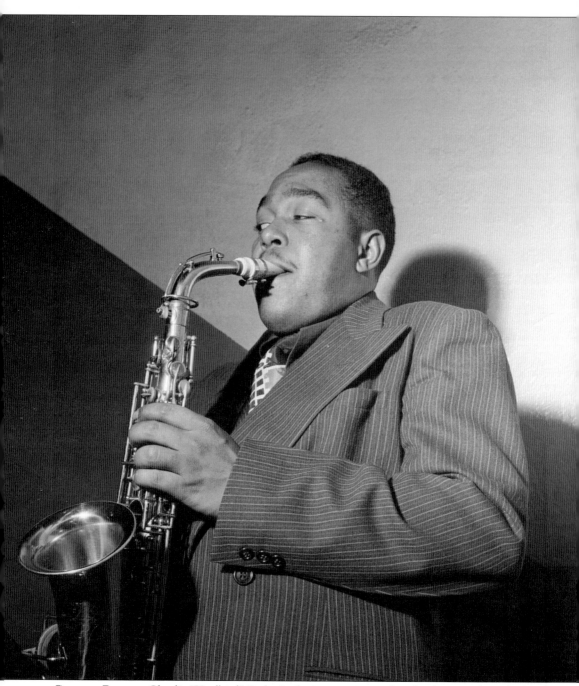

**CHARLIE PARKER.** Charlie "Yardbird" Parker's playing was magical, rich, clean, and precise, and he always found the pretty notes. He was able to play what he felt deep down inside of him, and people understood it in a beautiful way. He often chose the high notes of the chords as a melodic line and then complemented it with the right harmonic progression. He was able to internalize music to such a degree that his signature sound belonged only to him. His style had no boundaries. He was pure art mixed with genius.

**NAT KING COLE AND HIS TRIO AT THE SPOTLITE CLUB.** Nat King Cole became successful as a jazz pianist and singer in California before coming to New York. During World War II, the Nat King Cole Trio was signed to Capitol Records with Nat King Cole on piano, Oscar Moore on guitar, and Johnny Miller on bass. They achieved a succession of hit songs, including "Unforgettable" and "The Christmas Song." The original bass player was Wesley Prince, and Lee Young often was hired as the drummer. Nat King Cole was considered a leading jazz pianist, songwriter, and vocalist as well as a promoter of the revolutionary trio lineup of piano, guitar, and bass in a time when big bands and swing orchestras were popular.

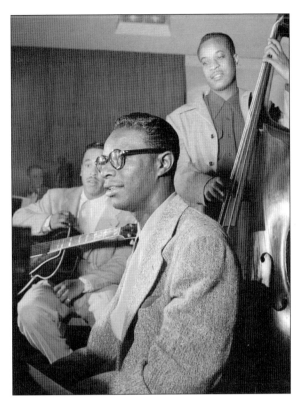

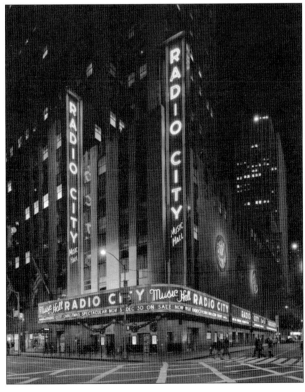

**RADIO CITY MUSIC HALL.** Radio City Music Hall, located in Rockefeller Plaza, opened its doors on December 27, 1932, and soon became known as the "Showplace of the Nation." The hall first started out with lavish stage shows featuring a variety of entertainers from Hollywood, vaudeville, and Broadway. It was also the stage for many of the most famous jazz musicians from Fifty-second Street. Its lavish foyer and balcony have been restored to their golden luster. It is still a vibrant music hall, home to the Rockettes. (Courtesy of Joseph Kinney.)

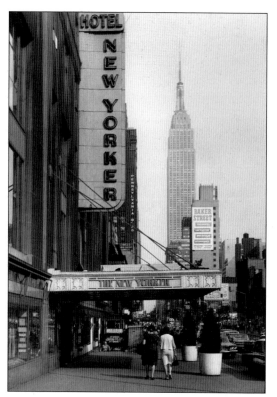

NEW YORKER HOTEL AND THE EMPIRE STATE BUILDING. The Terrace Room of the New Yorker Hotel was center stage for such greats as the Benny Goodman Orchestra, Paul Whitman Orchestra, Duke Ellington, Count Basie Orchestra, Stan Kenton's Progressive Jazz Orchestra, Bernie Cummins Orchestra, and Buddy Rich Orchestra. It was at its peak during the swing era; one could have dinner in the Terrace Room for $1.75. Also at that time, the Empire State Building, in the background, was the tallest structure in the world with 100 floors; the foundation of the Empire State Building is two acres. The Empire State Building, Art Deco in style, was completed at the height of the Great Depression. It would take almost 10 years before the Empire State Building could rent out all of its office space. (Courtesy of Joseph Kinney.)

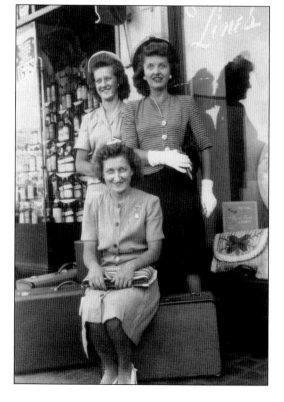

GIRLFRIENDS FOREVER! Getting ready for a trip to New York City, Elizabeth Parowski and her girlfriends Virginia and Sophie Kosakowski are shown in front of their house on Sixteenth Street in Bayonne, New Jersey. World War II had just ended, and there was plenty to celebrate! The glamorous nightclubs in New York City were like a magnet that attracted thousands of young couples who would fall in love there. This is the girls' last photograph as single women; by the next year, all three girlfriends would be engaged and married. (Author's collection.)

NEW YORKER HOTEL. Pictured is the Art Deco–style New Yorker Hotel at night. The New Yorker Hotel hosted the most famous jazz musicians, including Benny Goodman, Tommy Dorsey, Artie Shaw, Glenn Miller, and many others. It was home to the famous Nikola Tesla, inventor of alternating current electricity. The hotel has an Egyptian Art Deco–decorated underground tunnel to Pennsylvania Station, which is now sealed off. Also, 60 feet below the New Yorker Hotel was once the largest power plant in the United States during the jazz era. Though no longer a power plant, the area is still located adjacent to the famous Hammerstein Ballroom. (Courtesy of Joseph Kinney.)

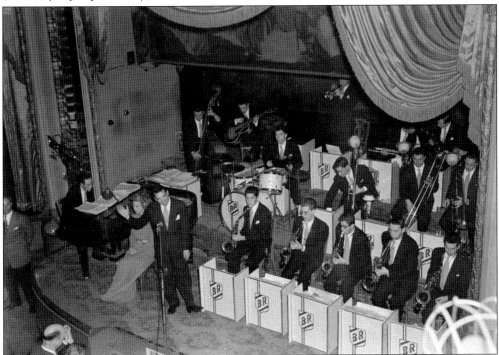

BUDDY RICH. Pictured and listed in various order are bandleader Buddy Rich, Stanley Fishelson, Tommy Allison, Phil Gilbert, Bill Howell, Mario Daone, Bob Ascher, Chunky Koenigsberg, Eddie Caine, Jerry Thirkeld, Allen Eager, Mickey Rich, Harvey Levine, Harvey Leonard, Gene Dell, and Tubby Phillips at the Arcadia Ballroom in New York City. Buddy Rich was one of the greatest jazz drummers of all time; he played with such greats as Benny Goodman, Joe Marsala, Artie Shaw, and guitarist Jack Lemaire. He will live forever as possible the world's greatest drummer.

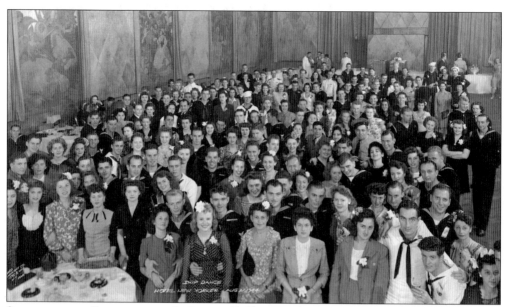

**SERVICEMEN AND SERVICEWOMEN.** At the grand ballroom at the New Yorker Hotel, victory dances were common as everyone was celebrating the end of World War II. (Courtesy of Joseph Kinney.)

**BETTY GEORGE, COPACABANA.** This is a picture of Betty George at the legendary Copacabana nightclub, one of the few remaining nightclubs from the golden era of jazz. When Prohibition ended in 1933, nightclubs began to boom again in New York, starting with the Stork Club, 21 Club, El Morocco, and the Copacabana. This is the inside of the Copacabana at 10 East Sixtieth Street in New York City; the nightclub was owned by Monte Proser and his infamous business partner Frank Costello, a notorious mob boss. The underworld controlled the jazz clubs and played a big role in the development of jazz by allowing it to thrive in its nightclubs.

GUY LOMBARDO. This is a picture of the Guy Lombardo Orchestra at the Starlight Ballroom, located on the top of the Waldorf Astoria. Guy Lombardo (sitting on the far right) and his brother Carmen (standing behind the microphone) were born in London, which was where they formed their first orchestra. Their first recording session was with the famous Gannet Studios, which was the same studio where trumpeter Bix Beiderbecke, Louis Armstrong, Baby Dodds, and Jelly Roll Morton recorded. The Guy Lombardo Orchestra will always be remembered for its New York City New Year's Eve specials and its rendition of the song "Auld Lang Syne."

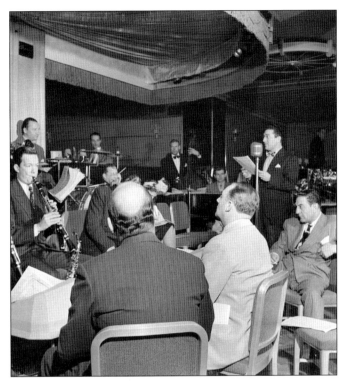

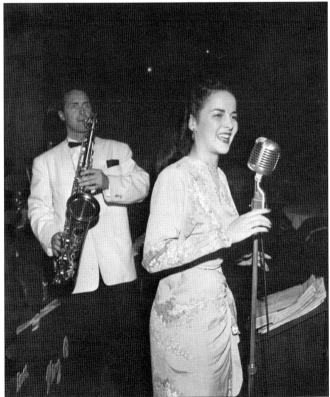

KING GUION AND HIS ORCHESTRA. Bandleader King Guion and his orchestra are performing in the Starlight Ballroom. King Guion was from San Francisco, California, and moved to New York to pursue a music career around 1940. He played tenor saxophone and clarinet mostly in swing and big band orchestras. The Waldorf Astoria, built by the Astor family, is still one of the most prestigious hotels in New York. The Starlight Ballroom had the orchestras of Glenn Miller, Tommy Dorsey, Bernie Cummins, Glenn Miller, and Guy Lombardo entertain its guests.

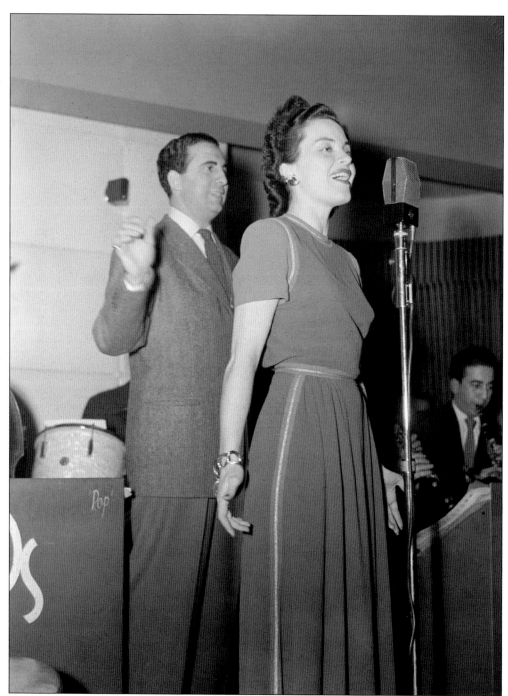

**WALDORF ASTORIA HOTEL.** This is a picture of the Dick Stabile Orchestra at the Waldorf Astoria. Dick Stabile was a bandleader who started out in Broadway pit orchestras. He was a successful recording artist for Decca, Bluebird, and ARC record labels. His band mostly worked in hotels in New York City. After the war, Dick remained in New York and worked with Jimmy Dorsey and Vincent Lopez. He later was the bandleader at the Hotel Roosevelt in New Orleans, which was where Emily Remler was hired and soon discovered by Herb Ellis.

**VILLAGE VANGUARD.** Josephine Premice is singing here at the Village Vanguard in New York City. Josephine was born in Brooklyn, and her parents were Haitian. She was a jazz singer and was known for her work on the Broadway stage where she dazzled audiences—so much so, she was the recipient of a Tony Award. The Village Vanguard is in the heart of Greenwich Village and was opened by Max Gordon in 1935. The successful nightclub was a haven for jazz musicians poets and artists. The Village Vanguard remains one of the hottest jazz clubs in New York and is still located in Greenwich Village. Almost every famous jazz musician has played here.

**NAT KING COLE TRIO.** The Nat King Cole Trio had a unique quality that really shined in its signature song "Route 66." The Nat King Cole Trio was one of the most successful bands that Columbia Records signed and had a whole new casual and swinging sound with simple arrangements. It was a new style for Cole, who previously had a more orchestrated and lush feel to his sound. The trio consisted of Nat King Cole on piano and vocals, Oscar Moore on guitar, and Johnny Miller on bass. Nat King Cole revolutionized the sound of jazz forever when he formed the first successful trio. Cole's daughter Natalie Cole would follow in her father's footsteps, becoming a huge star as well.

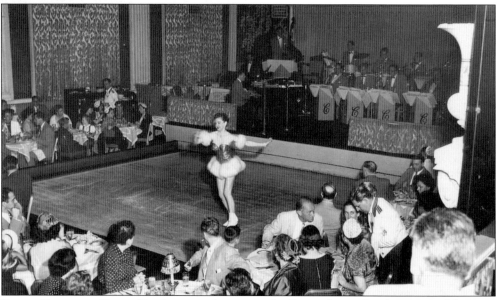

**BENNY GOODMAN.** Benny Goodman was known as the "king of swing" and was one of the most important men in making jazz a pure American art form. All the players as well as audiences loved him, and he was said to have been color blind to race issues. His early start was at the New Yorker Hotel, where his orchestra accompanied its ice shows. Benny Goodman was the first jazz bandleader to perform at Carnegie Hall, and this would help make jazz more mainstream, taking it from the honky-tonks and dance halls to more upscale venues. (Courtesy of Joseph Kinney.)

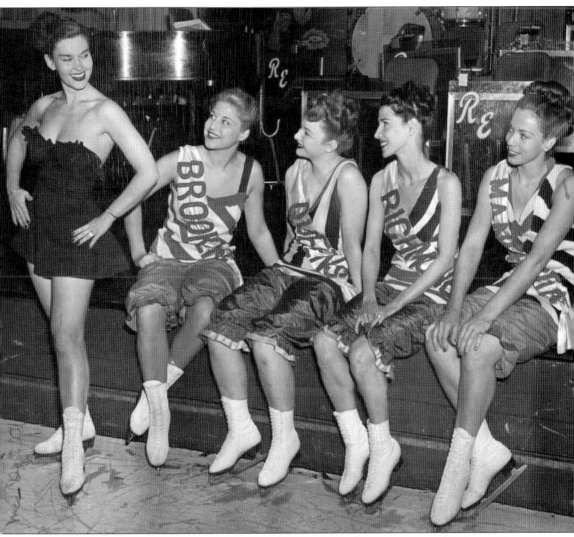

**ICE-SKATERS.** Here, ice-skaters at the New Yorker Hotel are shown preparing for the ice show. Note the orchestra equipment in the background. Both the Glenn Miller Orchestra and the Benny Goodman Orchestra played for most of the ice shows at the New Yorker. The ice shows were very elaborate and would pave the way for Disney on Ice and the Ice Shows at Madison Square Garden. (Courtesy of Joseph Kinney.)

**HARRIET HILLIARD.** This glamorous photograph of Harriet Hilliard captures the jazz-age era. Harriet was a singer, actress, and entertainer who married bandleader Ozzie Nelson. Her highlights include a contract with RKO Radio Pictures, CBS, and, in the 1950s, her radio, and later television, show *The Adventures of Ozzie and Harriet*. Their son Ricky Nelson also became a huge television star in the 1950s.

**BRILL BUILDING.** Every struggling musician, songwriter, bandleader, and artist knocked on the big gold door at the front of the Brill Building on Broadway and Forty-ninth Street, located in the heart of songwriter row and the historic musical Tin Pan Alley neighborhood. During the golden age of jazz and even today, the Brill Building has been known to house many important music publishers, studio executives, music agents, and entertainment lawyers. (Courtesy of Joseph Kinney.)

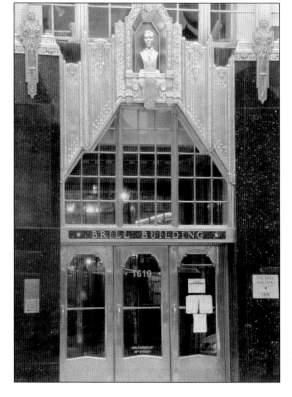

**Pee Wee Russell, Muggsy Spanier, Miff Mole, and Joe Grauso, c. June 1946.** Pictured are, from left to right, Pee Wee Russell, Muggsy Spanier, Miff Mole, and Joe Grauso at Nick's Tavern in Greenwich Village. Pee Wee Russell was an amazing jazz musician who was a staple in the New York jazz scene for almost 50 years. The New Jersey Jazz Society still has an annual Pee Wee Russell Memorial Stomp to help promote and keep alive the traditional style of jazz. Russell began his career playing Dixieland jazz but incorporated elements of newer developments such as swing, bebop, and free jazz.

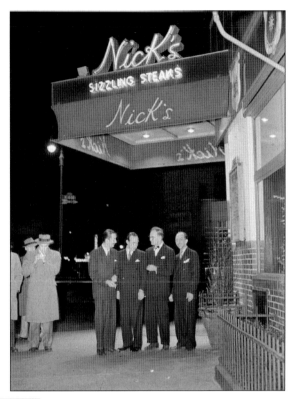

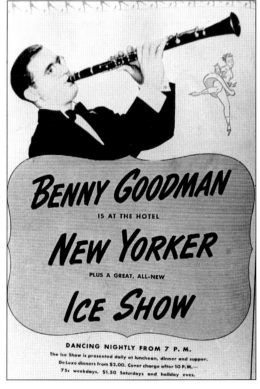

**New Yorker Hotel.** This program was used to promote an ice show, paired with the Benny Goodman Orchestra, at the New Yorker Hotel. These shows were very popular in the 1940s. The New Yorker Hotel was one of the hottest jazz destinations with two restaurants and the famous Terrace Room, which was where an ice rink was brought in. The Unification Church purchased the building in 1975 and is responsible for restoring this historical jazz palace and preserving a huge part of jazz history. Since reopening as a hotel in 1994, it has undergone approximately $100 million in improvements. (Courtesy of Joseph Kinney.)

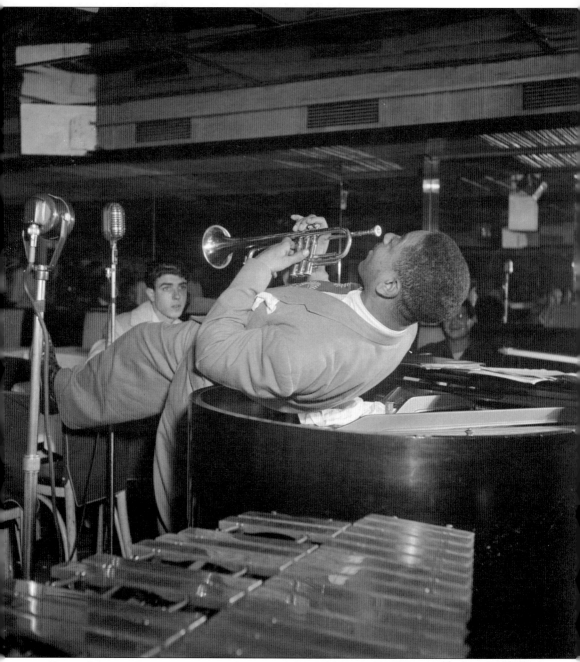

**DIZZY GILLESPIE PLAYING AT THE CLUB DOWNBEAT.** In this mid-1940s picture, Dizzy Gillespie is involved in the movement called Afro-Cuban music, which blended African, Cuban, and Latin American sounds with swing and salsa. This was the beginning of the bebop. Dizzy Gillespie began working with Congo player Chano Pozo and Mario Bauza, a Latin jazz trumpet player, and they experimented with their new sound in New York jazz clubs on Fifty-second Street. This was when Cuba was a popular vacation destination, and it led to a lot of musicians from Cuba coming to New York to work with the bands of Chick Webb, Cab Calloway, and Dizzy Gillespie.

**BILLY ECKSTINE.** William "Billy" Clarence Eckstine was a singer, bandleader, composer, and arranger of the swing era who arrived in New York from Philadelphia. Billy Eckstine's smooth and velvet voice helped to launch his career while breaking down color barriers and becoming one of the first romantic black males in jazz. He is most famous for his collaboration with Sarah Vaughan; they recorded the songs of songwriter Irving Berlin. Billy's signature song "I Apologize" is now in the Grammy Hall of Fame.

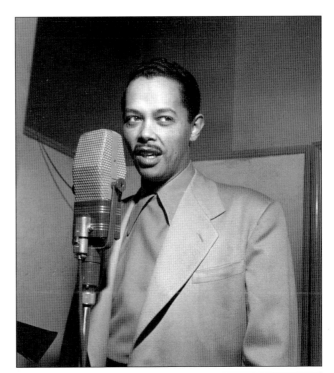

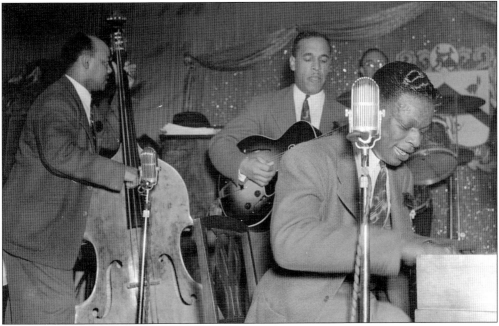

**NAT KING COLE.** In this picture, Nat King Cole is playing on the piano with his trio at Café Society, located downtown. There was also a Café Society that was located uptown. Nat King Cole's revolutionary trio, which had a lineup of piano, guitar, and bass in the time of the big bands, became a huge success. Cole was a leading jazz pianist and appeared in the first Jazz at the Philharmonic concert series. He influenced the amazing careers of Art Tatum, Oscar Peterson, Ray Charles, and Stevie Wonder.

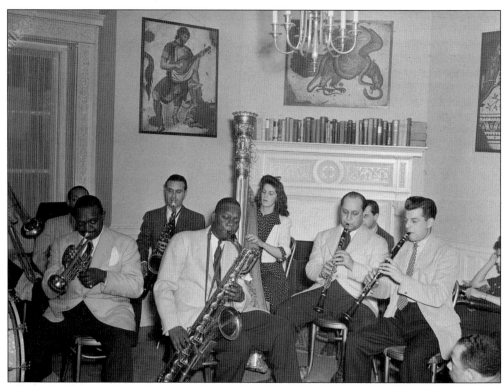

ADELE GIRARD, TURKISH EMBASSY, 1945. Adele Girard's was one of the few female musicians to have a successful career on Fifty-second Street. She started her career as a singer and piano player with the Dick Stabile Orchestra and later would work with the Teagarden Brothers at the Hickory House for almost 10 years, playing the piano, arranging, and composing songs.

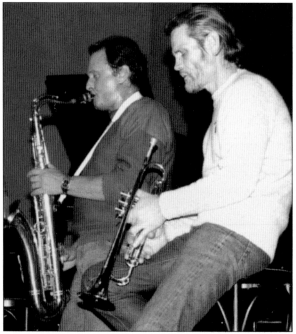

GERRY MULLIGAN AND CHET BAKER, CARNEGIE HALL. Chet Baker on trumpet (left) and Gerry Mulligan on baritone saxophone (right) play at a sold-out performance at Carnegie Hall. Gerry Mulligan's big break came when he moved to New York City in 1946 and was hired to play with Gene Krupa, and together, they would record the songs "Birdhouse" and "How High the Moon." At the event pictured, Gerry and Chet were performing as the Gerry Mulligan Quartet, which also included Jimmy Rowles on piano and Joe Mondragon on bass. Some of their most successful recordings together are found on the *Complete Pacific Jazz Recordings of the Original Gerry Mulligan Quartet with Chet Baker.*

CENTRAL PARK, NEW YORK, 1946. This is a picture of big band singer Doris Day (right) and her singer friend Kitty Kallen. They met while they both worked with Jimmy Dorsey's orchestra. Doris Day also sang with Les Brown and Harry James. While with the Jimmy Dorsey Orchestra, she recorded the hit song "Bésame Mucho (Kiss Me Much)." She also sang many duets with Bob Eberly, and some of her hits include "I Hear a Rhapsody," " Brazil," and "Stairway to the Stars."

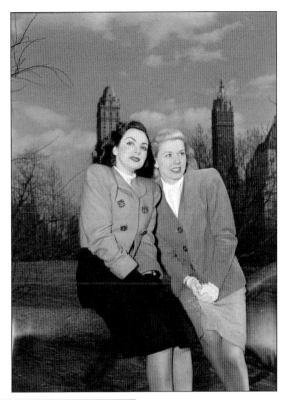

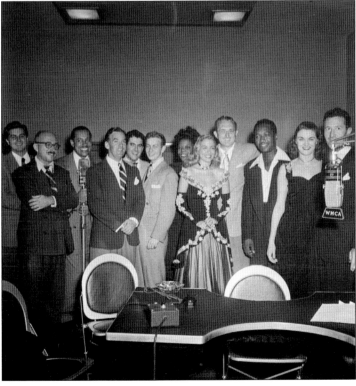

WMCA, C. OCTOBER 1947. Every person in this picture was a well-known musician in New York City in 1947. From left to right, Johnny Desmond, Martin Block, Cab Calloway, Mel Tormé, Georgie Auld, unidentified, Mary Lou Williams, Margaret Whiting, Tommy Dorsey, Josh White, Beryl Davis, and Ray McKinley gathered because they were working at WMCA, which was a popular studio. The WMCA Studio was where "The Christmas Song" was written and recorded, becoming a huge hit for Nat King Cole.

THE WOODY HERMAN ORCHESTRA, CARNEGIE HALL, C. APRIL 1946. The Woody Herman Orchestra was known for its swinging hard bop and exuberant dance bands. Woody and his orchestra had a successful concert at Carnegie Hall, and they were signed to Columbia Records. Some of Woody's favorite songs included "Caldonia," "Apple Honey," "Blue Flame," and "Summer Sequence." Those pictured are conductor Woody Herman,

FRANKIE LAINE IN FRONT OF THE PARAMOUNT THEATRE. Frankie Laine was a big band and swing singer who was often compared to Frank Sinatra. Laine said, "I can still close my eyes and visualize its blue and purple label. It was a Bessie Smith recording of 'The Bleeding Hearted Blues,' with 'Midnight Blues' on the other side. The first time I laid the needle down on that record I felt cold chills and an indescribable excitement. It was my first exposure to jazz and the blues, although I had no idea at the time what to call those magical sounds. I just knew I had to hear more of them!"

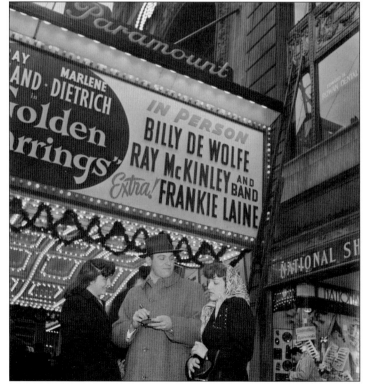

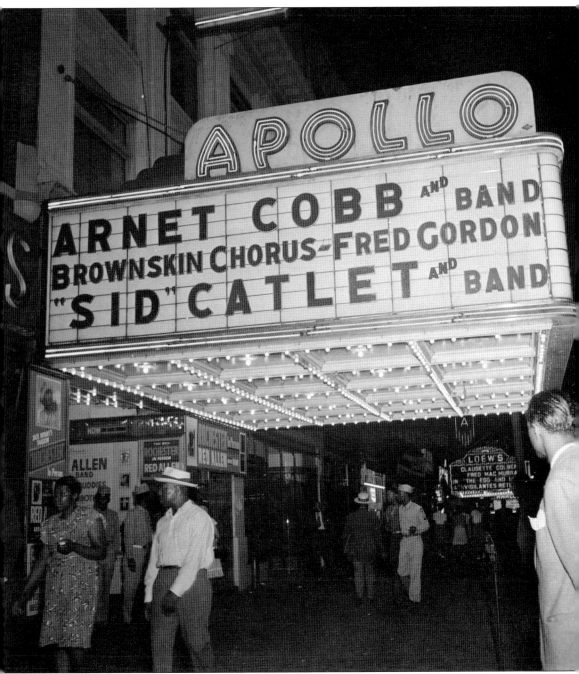

**APOLLO THEATER.** This is a picture of the Apollo Theater in Harlem, which became the most famous club featuring African American performers. The theater is located at 253 West 125th Street and once hosted artists Ella Fitzgerald, Sarah Vaughn, Lena Horne, Duke Ellington, and countless others. Jazz musicians, as well as rich audiences, were drawn to Harlem because of the abundance of nightlife. It was a glamorous place that was thriving and was the historical setting for the Harlem Renaissance. Duke Ellington's popular song "Take the A Train" was written about taking the subway to where the hot sounds of jazz were located in Harlem.

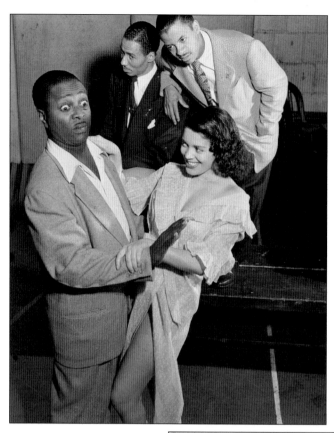

**Louis Jordan Dancing at the Paramount Theatre, c. July 1946.** Louis Thomas Jordan was a dancer, songwriter, and bandleader who was sometimes called "the father of the rhythm and blues." He was popular until the early 1950s. His most famous recordings include "Let the Good Times Roll," "Bean and Corn Bread," and "Caldonia." He was highly popular with both black and white audiences during the swing era and was ranked as one of the Greatest Artists of All Time by *Rolling Stone* magazine.

**Benny Goodman.** Benjamin "Benny" Goodman was born on May 30, 1909, in Chicago, Illinois, and everyone knew him as the "king of swing." He was a child prodigy who mastered the clarinet before he turned 10. Benny Goodman moved to New York City when he was in his early 20s and formed one of the most integrated bands during a period of time when segregation existed. Some of his most famous songs include "Honeysuckle Rose," "Night and Day," and "What a Little Moonlight Can Do." He became famous while playing at the New Yorker Hotel. (Courtesy of Joseph McKinney.)

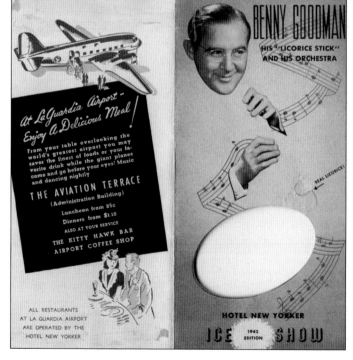

LEONARD BERNSTEIN. Leonard Bernstein (left) is pictured here at Carnegie Hall in New York City in 1946. He was world-renowned composer, pianist, arranger, author, and conductor with a body of work that included *West Side Story*, *Candide*, *On the Town*, and *Silver Linings Playbook*. He started as a singer waiting tables in Chinatown and soon found work as a music arranger. He was very eccentric and a musical genius.

SAM DONAHUE, AQUARIUM, C. DECEMBER 1946. Sam Donahue (March 18, 1918–March 22, 1974) was a swing musician who played tenor saxophone as well as the trumpet and was a musical arranger. He left Detroit, Michigan, when he was hired by Gene Krupa to play in New York. He is best known for his work with Gene Krupa, Tommy Dorsey, Benny Goodman, and Stan Kenton. (Courtesy of Joseph Kinney.)

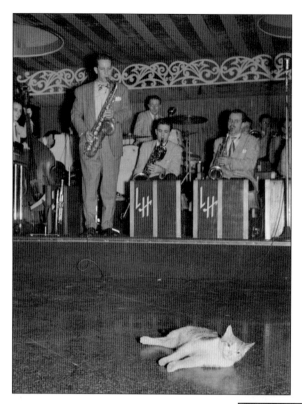

**SAM DONAHUE, AQUARIUM, C. DECEMBER 1946.** Sam Donahue (standing) became famous playing the saxophone in the bands of Gene Krupa, Harry James, and Benny Goodman. He soon would replace Artie Shaw during World War II, when Artie enlisted in the war. When the war ended, Donahue led an orchestra that had several successful recordings for Capitol Records. As a bandleader, he gained fame with his songs "A Rainy Night in Rio" and "Just the Other Day." He is the father of guitarist Jerry Donahue. (The cat pictured was named Hep.)

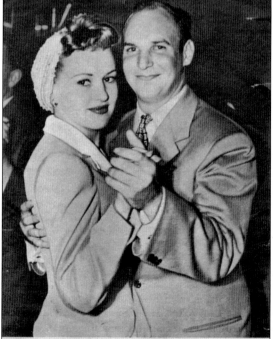

They, too. Another divorced pair from Hollywood succumb to the reunion fever under the lure of New York's nite lites, as Betty Grable and her ex-husband, Jackie Coogan, again find happiness together at the Stork Club.                                          (By Acme)

**MILLION DOLLAR LEGS!** Betty Grable was captured dancing with her ex-husband Jackie Coogan at the Stork Club. She later fell in love with and married Henry James, a musician, bandleader, and actor. Betty Grable was the girl with the "million dollar legs," which were insured by the Lloyds of London for $1 million. She was the biggest pinup model during World War II. (Author's collection.)

**EUGENE BERTRAM "GENE" KRUPA.**
Drummer Gene Krupa is one of the
greatest jazz drummers of all time. He
joined the Benny Goodman Orchestra,
where his featured drum work made
him a star on the band's hit "Sing,
Sing, Sing." He was very flamboyant
and had an enormous amount of
energy and technique. After the gigs
ended on Fifty-second Street, he went
to Hollywood and was in the movie
*Some Like It Hot* in the 1950s with
Marilyn Monroe. On a down note,
Gene Krupa was arrested for possession
of marijuana cigarettes and had to
serve a short jail sentence. He later
taught Kiss drummer Peter Criss.

**CHARLES DELAUNAY, FIFTY-SECOND
STREET, C. OCTOBER 1946.** Charles
Delaunay came to the United
States with Django Reinhardt to
play with Duke Ellington, and
they remained friends their entire
lives. In 1935, he founded *Le Jazz
Hot*, which is one of the oldest jazz
magazines, and was bandleader of
the Hot Club. He was a member of
the Resistance during World War
II and, in 1948, was the founder of
the record label Disques Vogue.

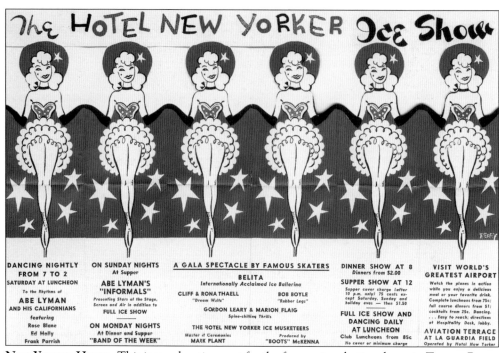

The HOTEL NEW YORKER Ice Show

| DANCING NIGHTLY FROM 7 TO 2 | ON SUNDAY NIGHTS At Supper | A GALA SPECTACLE BY FAMOUS SKATERS | DINNER SHOW AT 8 Dinners from $2.00 | VISIT WORLD'S GREATEST AIRPORT |
|---|---|---|---|---|
| SATURDAY AT LUNCHEON | ABE LYMAN'S "INFORMALS" | BELITA Internationally Acclaimed Ice Ballerina | SUPPER SHOW AT 12 | Watch the planes in action while you enjoy a delicious meal or your favorite drink. |
| To the Rhythms of ABE LYMAN AND HIS CALIFORNIANS | Presenting Stars of the Stage, Screen and Air in addition to FULL ICE SHOW | CLIFF & RONA THAELL "Dream Waltz"   BOB BOYLE "Rubber Legs" | Supper cover charge (after 10 p.m. only) 75 cents except Saturday, Sunday and holiday eves — then $1.50 | Complete luncheons from 75c; full course dinners from $1; cocktails from 25c. Dancing. |
| featuring Rose Blane Ed Holly Frank Parrish | ON MONDAY NIGHTS At Dinner and Supper "BAND OF THE WEEK" | GORDON LEARY & MARION FLAIG Spine-chilling Thrills THE HOTEL NEW YORKER ICE MUSKETEERS Master of Ceremonies   Produced by MARK PLANT   "BOOTS" McKENNA | FULL ICE SHOW AND DANCING DAILY AT LUNCHEON Club Luncheons from 85c No cover or minimum charge | . . . Easy to reach; directions at Hospitality Desk, lobby. AVIATION TERRACE AT LA GUARDIA FIELD Operated by Hotel New Yorker |

NEW YORKER HOTEL. This is an advertisement for the famous ice-skating shows in Terrace Room of the New Yorker Hotel. On a daily basis, the Terrace Room produced hand-painted programs to promote ice and jazz shows. (Courtesy of Joseph Kinney.)

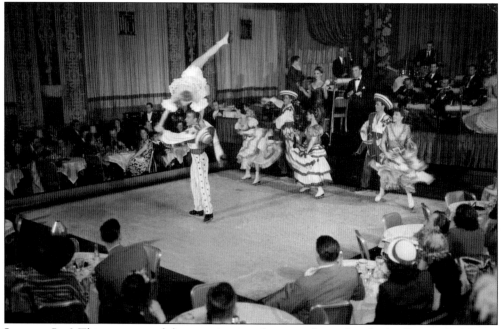

JAZZ ON ICE! This was one of the amazing ice shows performed with the Benny Goodman Orchestra. It was a fabulous ice show that attracted people from around the world. This was the first time that there was an indoor ice show that was performed to live jazz music. (Courtesy of Joseph Kinney.)

**A BENNY GOODMAN PROGRAM AT THE NEW YORKER HOTEL.** Charlie Christian was discovered during a break in a Goodman concert. Christian started playing "Rose Room," and Goodman was immediately impressed. The 45-minute performance would make him a hit on the electric guitar, and he remained in the Benny Goodman Sextet for two years. He wrote many of the group's arrangements. (Courtesy of Joseph Kinney.)

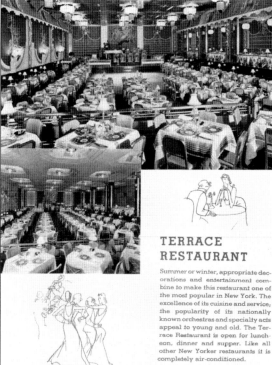

**TERRACE ROOM.** This is a picture of New Yorker Hotel's Terrace Room, which still exists today. It was the room where the ice shows and big band concerts were held. At one point, the Terrace Room was as famous as the Starlight Ballroom in the Waldorf Astoria. It is now rented and being used as a television studio. (Courtesy of Joseph Kinney.)

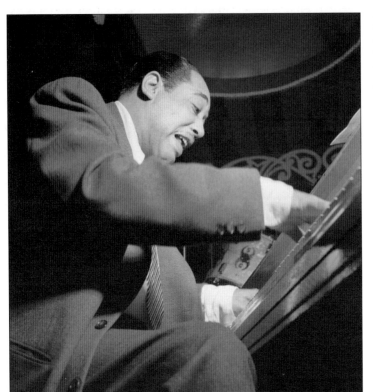

**DUKE ELLINGTON, AQUARIUM, 1956.** Charlie Christian is one of the greatest jazz guitarists of all time. Benny Goodman introduced Charlie Christian to Duke Ellington, who was at first not impressed. He was not sure of the idea of an electric guitar and did not like the tone it produced. However, when Charlie Christian sat in with Goodman and played his famous solo "Rose Room," Duke Ellington was sold on the new guitarist. Charlie Christian died a short time later at the age of 26.

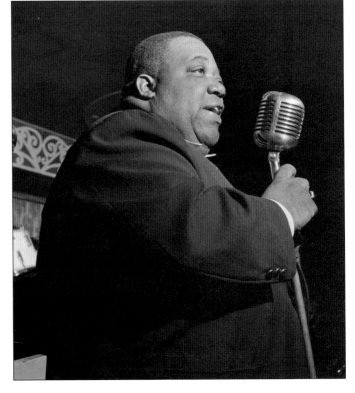

**JIMMY RUSHING, AQUARIUM, C. OCTOBER 1946.** Jimmy Rushing was the singer for Duke Ellington for many years and was known for his gravel-pitch tones. He went on to play with the Count Basie Orchestra and then was very successfully as a bandleader in New York City. He was also a musical arranger and songwriter and served as the inspiration for many other singers.

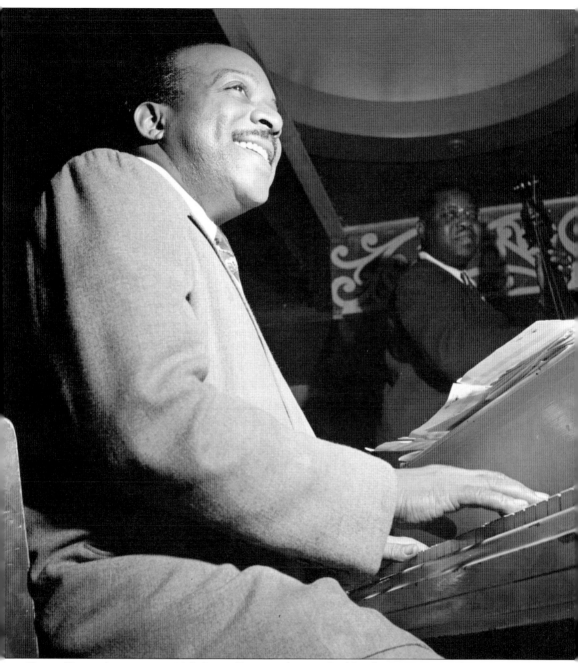

**COUNT BASIE, AQUARIUM, 1946.** Count Basie was born in Red Bank, New Jersey, and was one of the most famous composers, piano players, and arrangers to have worked on Fifty-second Street. He worked with virtually every famous musician in jazz. A theater in Red Bank, New Jersey, was built in his honor.

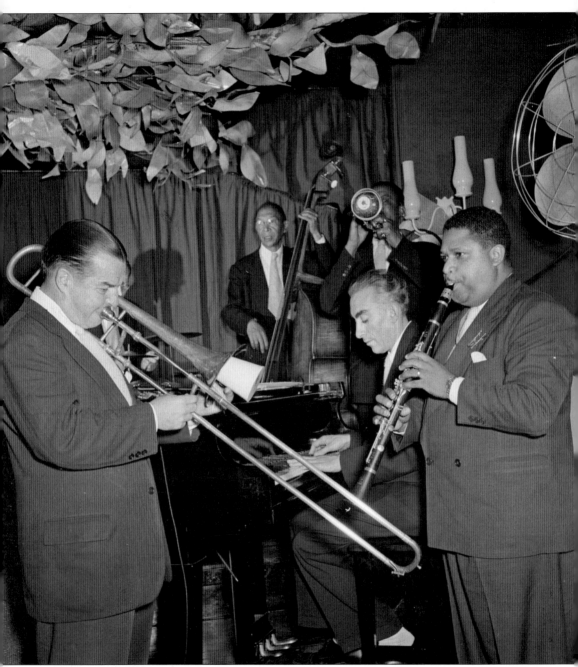

**JACK TEAGARDEN, FAMOUS DOOR, 1947.** Jack Teagarden (August 20, 1905–January 15, 1964) was a successful jazz trombonist, bandleader, composer, and vocalist, known as the "father of jazz trombone." His sound was in the style of traditional New Orleans with its bold brass sounds. He played everything from swing, ragtime, Dixieland, and big band during his stay in New York City. When bebop emerged, he was unable to find steady work. Duke Ellington was a staple from 1923 through the 1940s at the Famous Door Nightclub. Other players at the Famous Door included Count Basie, Junior Raglin, Juan Tizol, Barney Bigard, Ben Webster, Harry Carney, Rex William Stewart, and Sonny Greer.

**MARGARET WHITING AT THE FAMOUS DOOR, 1946.** Margaret Whiting was born in Detroit, and her father, Richard Whiting, was a famous composer. Whiting's singing ability had already been noticed early, and she would record many songs written by Johnny Mercer. When Mercer cofounded Capitol Records, he signed Margaret to one of Capitol's first recording contracts.

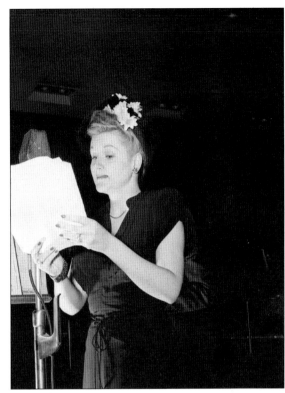

**MACHITO AND GRACIELA GRILLO, GLEN ISLAND CASINO, C. JULY 1947.** The Latin sound was becoming very popular in the 1940s. Machito and Graciela Grillo played Latin jazz mixed with Latin American rhythms. A brother-and-sister team, they made huge contributions in Afro-Latin jazz and salsa. They were to become a huge contribution in influencing Charlie Parker and Dizzy Gillespie as they moved toward bebop and modern jazz.

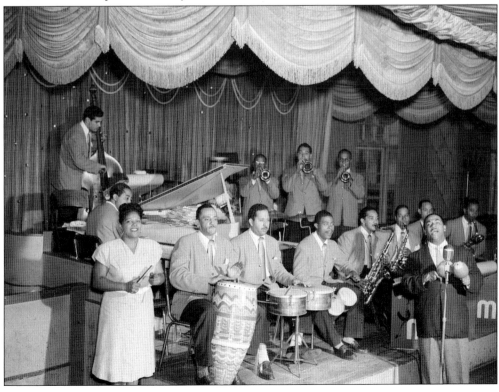

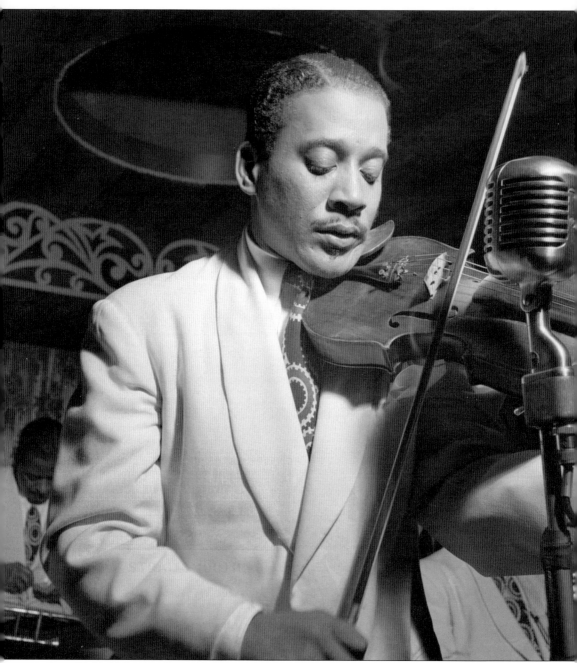

**RAY NANCE, AQUARIUM, C. NOVEMBER 1946.** Ray Willis Nance (December 10, 1913–January 28, 1976) was one of the best violinists of all time in jazz. He influenced almost every jazz violinist who came after him. Nance was multitalented and could play trumpet, violin, and sing. His most incredible moments came when he played with the Duke Ellington Orchestra; he is playing with the band in this 1946 picture.

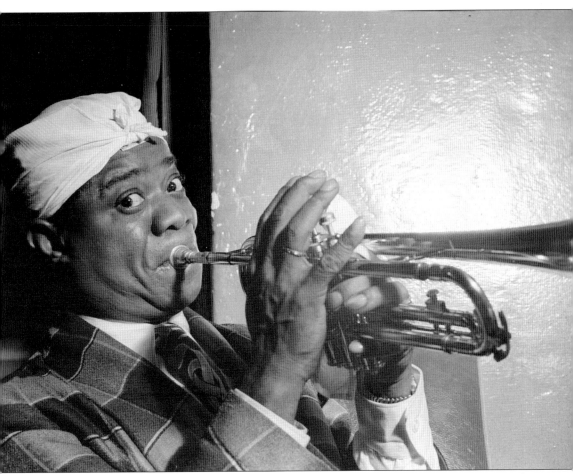

**Louis Armstrong, Aquarium, c. July 1946.** Louis Armstrong was from New Orleans and formed the original Hot Five. The group included Armstrong's wife, Lil Harden Armstrong, on piano, Kid Ory on trombone, Johnny Dodds on clarinet, and Johnny St. Cry on guitar and banjo. Louis Armstrong was considered one of the greatest jazz musicians of all time; there is even the Louis Armstrong House Museum in Queens that showcases all of his accomplishments.

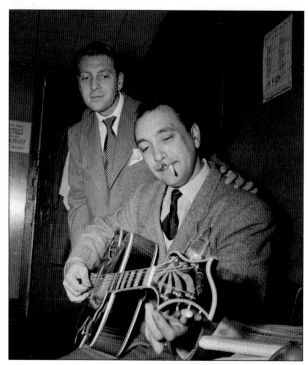

**DJANGO REINHARDT.** Gypsy guitarist Django Reinhardt toured with Duke Ellington in the United States in 1946 to less than stellar reviews. Django forgot to bring a guitar and expected a gold-plated guitar upon his arrival as well as a boatload of money. His requests did not happen, and Django was forced to borrow a guitar. He was also upset that his name did not appear on the flyer promoting the concert. The tour ended at Carnegie Hall, and Django arrived late and without a guitar. As years passed, Reinhardt would be considered one of the finest guitarists of all time.

**REX WILLIAM STEWART.** This is a picture of Rex Stewart Page, standing at right, playing his cornet at the Aquarium. Rex Stewart came to New York City to play with Fletcher Henderson after playing jazz on riverboats on the Potomac River. His unique style of making the cornet "talk," created by using half-valve effects, caught the attention of Duke Ellington, with whom he played for 11 years and cowrote the hit song, "Morning Glory." He was often compared to his major influencers, Louis Armstrong and Bix Beiderbecke. After the jazz scene ended, he began writing for *Playboy* and *Downbeat* magazines, became a Cordon Bleu chef in France, and opened a restaurant and restored a 100-acre farmhouse in Troy, New York, before settling down on the West Coast.

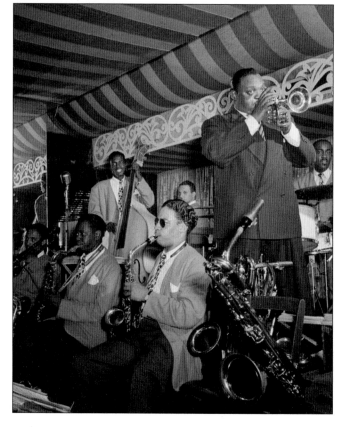

**SPARS MENU's.** Pictured is a World War II–themed hand-painted menu from the New Yorker Hotel. The theme of this menu is women at the battlefront. During World War II and for a few years after it ended, depictions of men and women at war were often used in advertising. (Courtesy of Joseph Kinney.)

SPARS *of the Coast Guard*
*guide craft of the sky and the ocean to happy landings*

THIRD OF A SERIES "WOMEN IN WAR" PRESENTED BY HOTEL NEW YORKER

WACS *learn their geography at first hand in exotic lands far from home*

FIRST OF A SERIES "WOMEN IN WAR" PRESENTED BY HOTEL NEW YORKER

**VICTORY AT WAR!** Pictured is a World War II–themed menu from the New Yorker Hotel. This was one of the many-hand painted menus that showed men who were fighting the war in either Europe or the Pacific. Everyday, a new hand-painted menu was designed for the patrons at the New Yorker Hotel. (Courtesy of Joseph Kinney.)

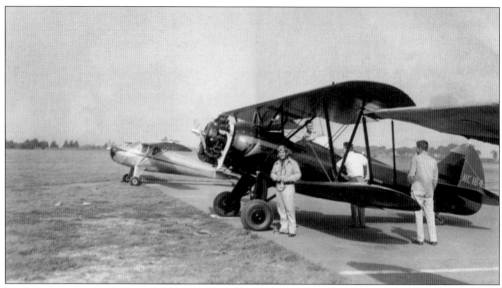

**LT. RICHARD DODD IN PORT MORESBY, NEW GUINEA, WORLD WAR II.** Lt. Richard Dodd is seen here on a landing strip at the ramshackle deepwater facility in Port Moresby, New Guinea. When the war ended, he left the Pacific theater and came back to Fifty-second Street to pursue his singing and songwriting dreams. His dreams quickly faded into stardust, and the world was never lucky enough to hear this almost-legendary singer and songwriter. (Author's collection.)

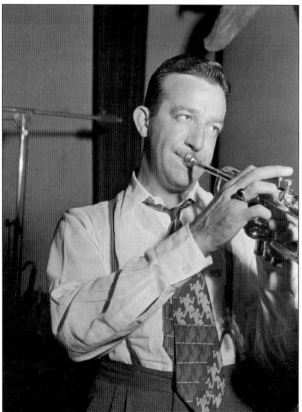

**HARRY JAMES, COCA-COLA RADIO SHOW REHEARSAL, C. 1946–1948.** Henry Haag "Harry" James (March 15, 1916–July 5, 1983) was an actor and musician. He was a well-known trumpeter who led a swing band during the 1930s and 1940s. He hired Frank Sinatra, the first bandleader to give Sinatra a break. He married Betty Grable, and they had two daughters and a very hard life together.

MARION HUTTON, SATIRE ROOM, AUGUST 1947. Marion Hutton was a singer and the older sister of actress Betty Hutton. Both sisters sang with the Vincent Lopez Orchestra. Glenn Miller saw Marion singing with that orchestra in 1938 when she was only 17 and invited her to audition for his band. He and his wife, Helen, also became the legal guardians of Marion and Betty Hutton. Marion remained an important part of the Glenn Miller Band until 1942, when Miller went to war. She next appeared with the Desi Arnaz Orchestra in 1947.

JOHNNY DESMOND AND MARGARET WHITING, CAFÉ SOCIETY, 1947. In the 1940s and 1950s, many artists would record the same song at about the same time, and some chart hits for Desmond were also major hits for other singers. Thus, Desmond's No. 12 hit "Guilty" was an even bigger hit for Margaret Whiting at position No. 4. Desmond's No. 17 "Because of You" was a No. 1 hit for Tony Bennett. Johnny Desmond and Margaret Whiting were great friends and sang on many recordings together.

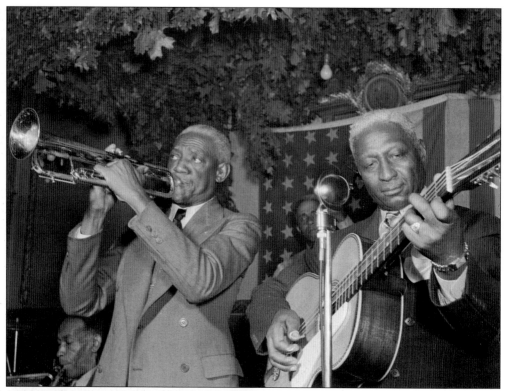

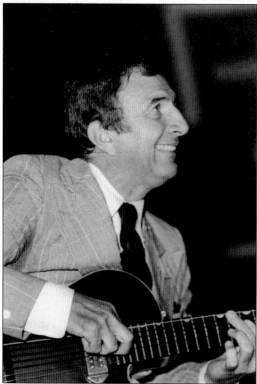

**BUNK JOHNSON AND HUDDIE "LEADBELLY" LEDBETTER, STUYVESANT CASINO, C. JUNE 1946.** Huddie William "Leadbelly" Ledbetter was a rambling man who endured poverty and a prison stint in Louisiana. Leadbelly traveled across the Deep South from the age of 16 in search of work in cotton fields. Despite his hard beginnings, he went on to become a legendary blues guitarist, 12-string guitarist, and singer. He is renowned for his songs "Rock Island Line," "Goodnight, Irene," "The Midnight Special," and "Cotton Fields."

**LEGENDARY BUCKY PIZZARELLI PLAYING AT THE BLUE NOTE IN NEW YORK CITY.** John "Bucky" Pizzarelli (born January 9, 1926) is a jazz guitarist and also the father of jazz musicians John and Martin Pizzarelli. Over the years, Pizzarelli worked with musicians Les Paul, Stéphane Grappelli, and Benny Goodman. Pizzarelli's style of playing was influenced Django Reinhardt and Freddie Green. (Courtesy of New Jersey Jazz Society.)

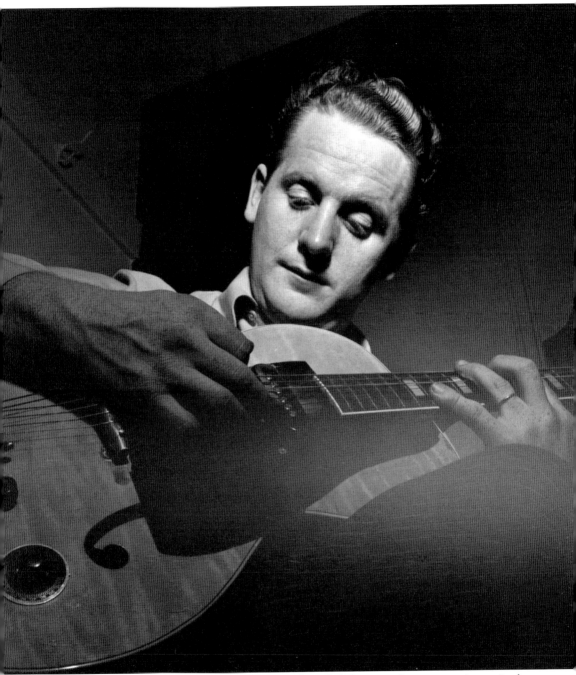

**LES PAUL, JANUARY 1947.** Les Paul, born Lester William Polsfuss, was the greatest pioneer in the advance of the electric solid-body guitar, which made the sound of rock and roll possible. He was a gifted jazz, country, and blues guitarist, songwriter, and inventor.

**WEDDING BELLS!** World War II is over, and wedding bells chime as Richard and Elizabeth Dodd wed at Mount Carmel Church in Bayonne, New Jersey. At the end of the war, more couples were married than in any other year in history. This played a significant role in the end of New York City jazz; more couples began moving from the city to the suburbs than any other time in history. Raising families, coupled with the onset of television and radio, soon replaced the need to visit nightclubs for entertainment. Jazz would forever be changed. (Author's collection.)

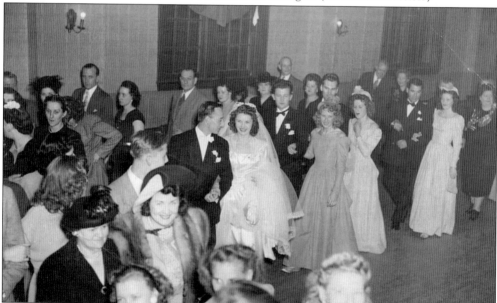

**WALDORF ASTORIA.** The Waldorf Astoria is the grandest place for a wedding, and here, Richard and Elizabeth (née Parowski) Dodd are pictured as newlyweds. The year was 1947, and it marked a turning point in New York City jazz. As Betty and Dick traded the glamour of New York City nightclubs and jazz to settle down and raise a family, the world seemed to follow them. Within two years, all of the major nightclubs on Fifty-second Street were gone, and the music scene in New York was moving into Greenwich Village, where the early roots of folk music and rock were emerging. Jazz has not had that sort of prominence again. (Author's collection.)

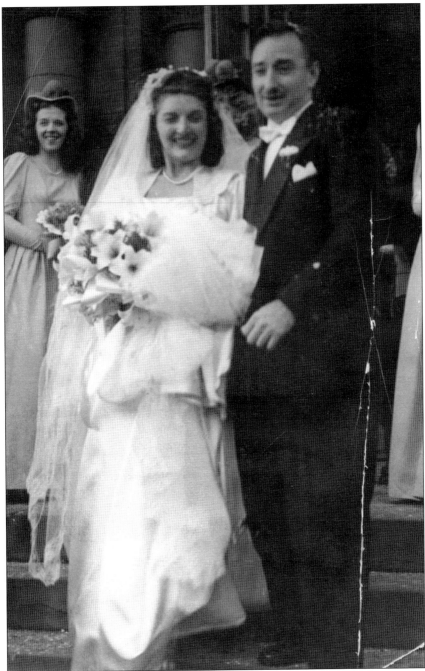

CONGRATULATIONS! On September 29, 1947, Richard Dodd and Elizabeth Parowski were among the many happy couples who married after the war ended. This portrait shows them after their wedding in front of the Mount Carmel Church in Bayonne, New Jersey. With 76 million born between 1947 and 1967, baby boomers are the largest generation in history and the first generation to grow up with television, air-conditioning, and rock and roll. This would coincide with the rapid decline of the famous jazz clubs on Fifty-second Street, which were now decadent burlesque and strip joints. Basically, the finest jazz musicians were out of work.

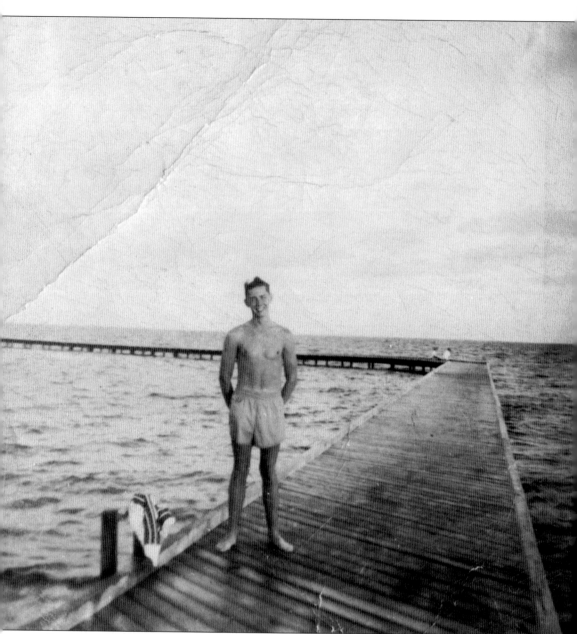

**STANDING ON THE DOCK OF THE BAY.** Many famous people who left their mark on jazz in New York City were born on the New Jersey side of the Hudson River and either swam in these waters or took a ferry across it to catch their dreams in New York City. Sarah Vaughan, Billie Holiday, Frank Sinatra, Bill Evans, Joe Cinderella, and countless others either were born in New Jersey or lived here before stardom. Here, George Parowski, the brother of Elizabeth Parowski, stands at the dock of Newark Bay in 1946 before heading to New York for a date with Catherine Dolan, his future wife. (Author's collection.)

# *Three*

# STEEL GARDENIAS

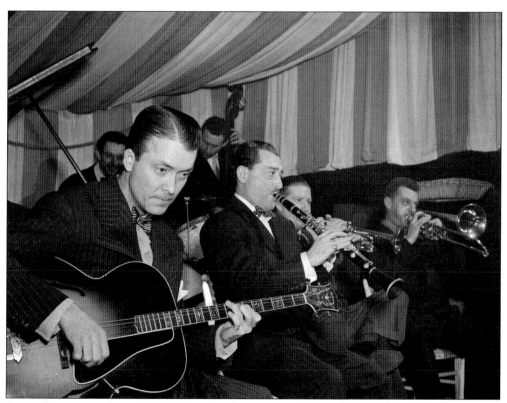

**EDDIE CONDON, C. JUNE 1946.** Eddie Condon was a guitarist who moved to New York City to pursue his dream of becoming a great jazz guitarist. He started out as an arranger for record labels, and he played with Louis Armstrong. He would go on to have a long and successful career with Commodore Records. He also owned a successful jazz club called Eddie Condon's, pictured here. The musicians shown are, from left to right, (first row) Eddie Condon, Tony Parenti, Wild Bill Davison, and Arthur Bradford "Brad" Gowans; (second row) Freddie Ohms and Jack Lesberg.

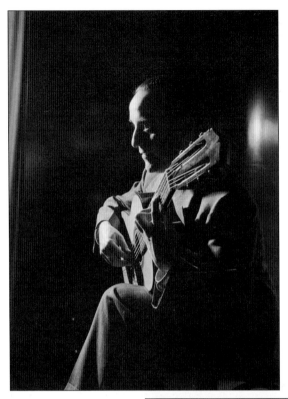

**VINCENT GÓMEZ, CAFÉ SOCIETY UPTOWN, C. JUNE 1946.** Vincent Gómez is pictured at the Café Society nightclub. He was born in Madrid, Spain, and worked as a musician in the red-light district of Madrid. When he was 25 years old, Gómez left Spain for New York to pursue a music career. He would become a very innovative jazz musician, pioneering and blending the Latin sound with the sounds of swing and big band.

**NAT KING COLE TRIO PERFORMING AT CAFÉ SOCIETY UPTOWN, GREENWICH VILLAGE, 1947.** Nathaniel Adams Coles (March 17, 1919–February 15, 1965), better known as Nat King Cole, was a brilliant musician who first gained early success as a jazz pianist. The audience loved the way he sang, and when he incorporated his singing into his signature trio sound, a huge star was born. His soft baritone voice recorded some of the most legendary hits of all time in the big band and jazz genres.

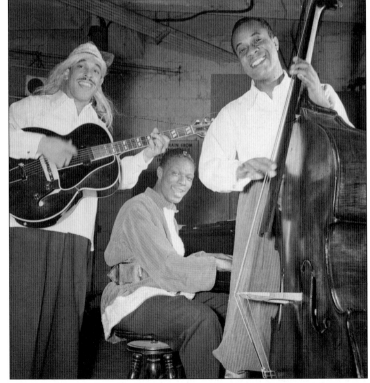

**Taft Jordan Playing Trumpet at the Aquarium on Fifty-Second Street, 1947.** Taft Jordan was a trumpeter. In the beginning of his career, Jordan played with the Chick Webb Orchestra from 1932 to 1942. The legendary Ella Fitzgerald would later replace him to become Chick Webb's first female singer. Jordan's later highlights included touring with Benny Goodman and playing on Miles Davis's *Sketches of Spain*.

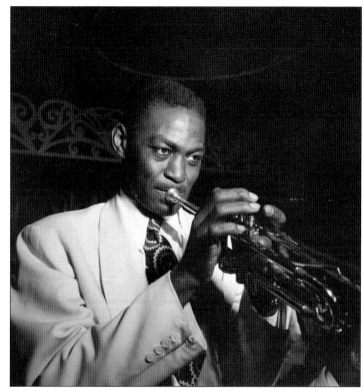

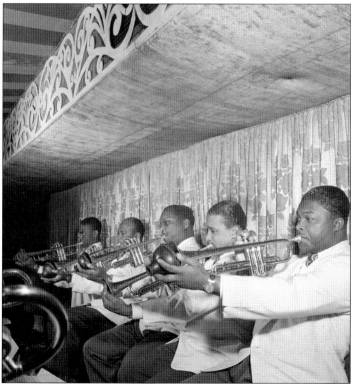

**Cat Anderson, Ray Nance, and Taft Jordan, Aquarium, November 1946.** Pictured are, from right to left, Cat Anderson, Ray Nance, two unidentified musicians, and Taft Jordan. William Alonzo Anderson (September 12, 1916– April 29, 1981) was known as Cat Anderson. Anderson played trumpet with the Duke Ellington Orchestra for nearly a decade. He had a remarkable tone, a range of five octaves, and could always hit the high notes in the higher registers. He played with Lionel Hampton, and they recorded the classic "Flying Home No. 2."

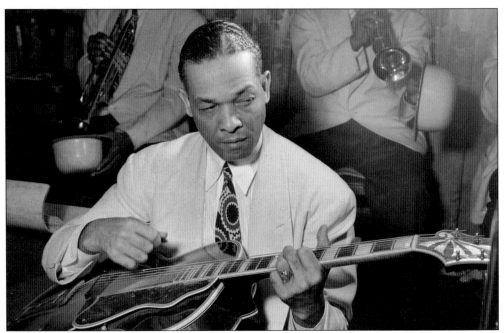

**FRED GUY.** This is a picture of Fred Guy on Fifty-second Street. Guy played guitar and banjo with Duke Ellington for almost 25 years, starting with his years at the Cotton Club and ending in the nightclubs along Fifty-second Street. He started out playing banjo but switched to guitar in the 1930s, when the rhythm section in jazz changed rapidly. He played a Gibson banjo and an L5 or L7 Gibson guitar.

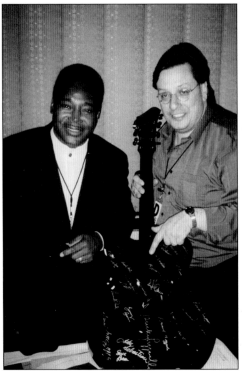

**GEORGE BENSON (LEFT) AND STEVE LUCAS.** George Benson is seen here with guitarist Steve Lucas from the Les Paul Trio. George Benson has had an extraordinary career. He was born in Pittsburgh, Pennsylvania, in 1943 and hit the path to jazz stardom when he moved to New York City and quickly met Wes Montgomery and Columbia Records executive John Hammond. Hammond was impressed with Benson and soon found him work with Herbie Hancock, Freddie Hubbard, Miles Davis, and many others. Benson signed a lucrative deal with Columbia Records in 1965. He is currently recording an album with Concord Records featuring the music of Nat King Cole with a 42-piece orchestra. A large portion of the proceeds will be donated to victims of Hurricane Sandy. (Courtesy of Steve Lucas.)

**ZANZIBAR CAFÉ.** In this picture, the guitar, bass, and drums are now center stage in New York and have replaced the big band sound and the swing orchestras. This was the beginning of when folk music started to emerge as well as popular music and early rock and roll. The clubs on Fifty-second Street quickly closed, and the music scene would move farther downtown to Greenwich Village where clubs like Birdland, Village Vanguard, and the Blue Note became the hottest places to be.

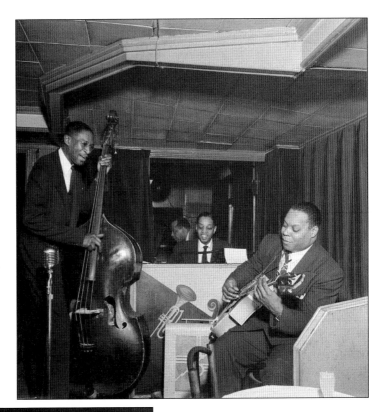

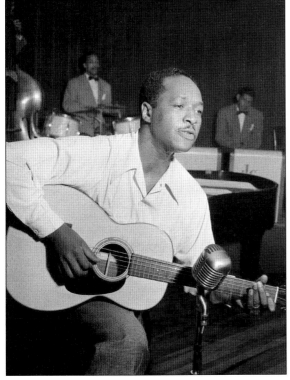

**TINY GRIMES PLAYING GUITAR AT THE ZANZIBAR CAFÉ, 1947.** Tiny Grimes was born in Newport News, Virginia, and moved to New York City in 1938. He started playing the electric four-string tenor guitar, and by 1943, he joined the Art Tatum Trio. He had a beautiful tone and made a number of recordings with Art Tatum. The early Tatum Trio recordings contain some of the most sophisticated single guitar lines of Tiny Grimes's guitar work.

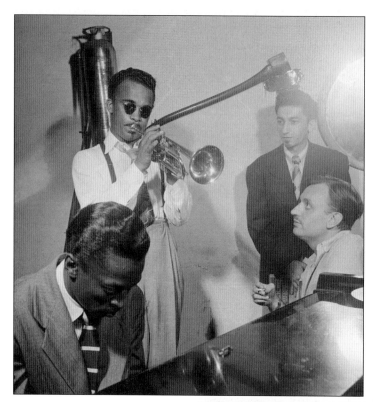

**HOWARD MCGHEE, SEPTEMBER 1947.** Howard McGhee (March 6, 1918–July 17, 1987) was one of the first bebop trumpeters. Known for having quick fingers and very high notes, he, along with Fats Navarro, influenced the next generation of hard bop trumpeters. He played with all of the greatest legends on Fifty-second Street and was a major force in jazz.

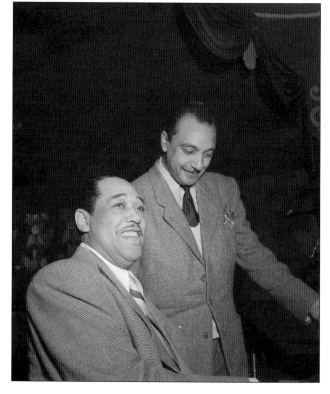

**DJANGO REINHARDT (STANDING) WITH DUKE ELLINGTON.** During a tour with Duke Ellington, Reinhardt never was given any solos but only a few tunes at the end each show. Reinhardt's favorite guitar was a Selmer jazz model, and it was the guitar he made famous. While usually smoking a cigarette, he played fast single-line solos, which he became known for. He is also remembered for having slighted his band mates in one instance when Duke Ellington invited the entire band, including Stéphane Grappelli, to tour with him, but Django did not relay the invitation to his bandmates. Django was the only one to accept the invitation.

BILL "BUDDY" DE
ARANGO, TERRY GIBBS,
AND HARRY BISS, CLUB
TROUBADOUR, 1948.
The Club Troubadour
was another legendary
jazz club on Fifty-second
Street and shared the
street with Three Deuces
and Kelly's Stable.
Harry Biss is on the far
left with Bill "Buddy"
de Arango at center
holding the guitar. Terry
Gibbs is to his right.

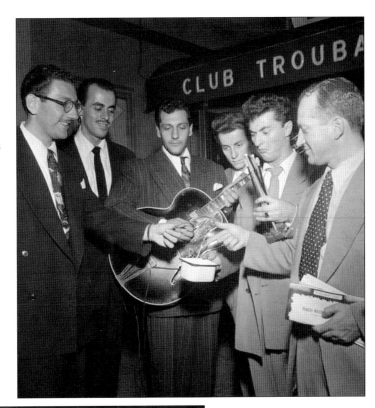

VIBRAPHONIST TERRY
GIBBS, GUITARIST
BUDDY DE ARANGO, AND
PIANIST HARRY BISS,
THREE DEUCES, JUNE
1947. Terry Gibbs was
a great jazz vibraphonist
and bandleader. He has
performed and recorded
with Tommy Dorsey,
Chubby Jackson, Buddy
Rich, Woody Herman, and
others. Terry Gibbs also
worked in the film and
television studios in Los
Angeles and New York.

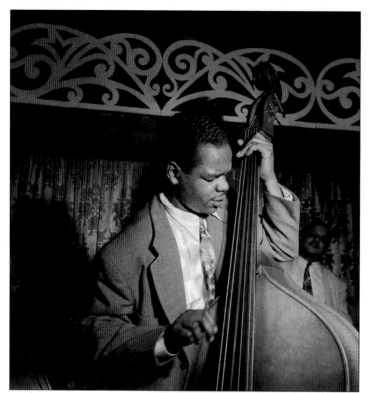

**JUNIOR RAGLIN, AQUARIUM, NOVEMBER 1946.** Alvin "Junior" Raglin was a swing jazz double-bassist player with a unique style. This may have been due to the fact that he started out on guitar but switched to bass to find more work. He played with the Duke Ellington Orchestra from 1941 to 1945. After leaving that orchestra, Raglin led his own quartet and also played with Ella Fitzgerald. He died young and was not featured on many recordings.

**FAMOUS DOOR NIGHTCLUB.** This is a photograph of the Deryk Sampson Trio with singer Lynn Carver. From left to right are guitarist Clair Dorward, pianist Deryk Sampson, Lynn Carver, and bassist Justin Arndt in 1947. The Famous Door nightclub at Vine and Willoughby Streets was the former Blue Heaven nightclub, owned by musician Louis Prima.

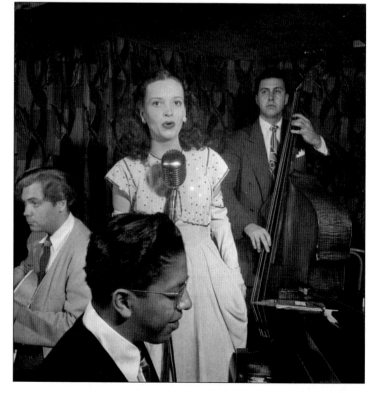

LES PAUL, FAT TUESDAY, NEW
YORK, NEW YORK, 1980S. Les Paul
is an icon and will live forever
in the heart and soul of every
aspiring rock guitarist as well
as in the Rock and Roll Hall of
Fame. His music can still be heard
everywhere, and his Les Paul guitar
is well known worldwide. At this
point in time, Les Paul and Mary
Paul divorced due to the brutal
touring schedules. Their son Rusty
Paul is an amazing bass player
carrying on his father's legacy
and playing with Steve Lucas.

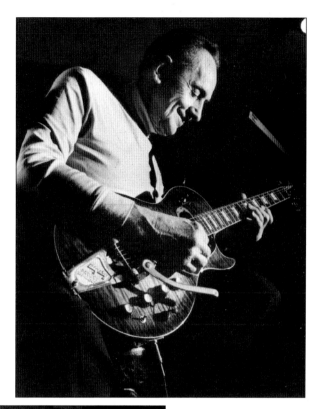

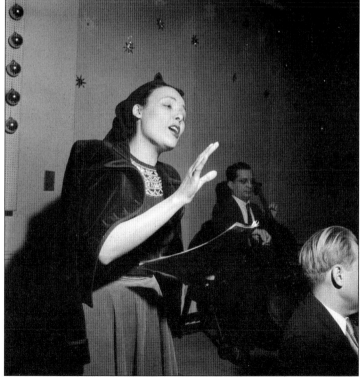

LENA HORNE SINGING
AT THE CAFÉ SOCIETY,
1947. Lena Horne
joined the chorus of
the Cotton Club before
moving to Hollywood,
where she had small
parts in such movies
as *Cabin in the Sky*
and *Stormy Weather*.
Her strong political
views led to her
becoming blacklisted
and unable to get
work in Hollywood.
She returned to New
York and continued
a successful career as
a singer on Broadway
and in nightclubs.

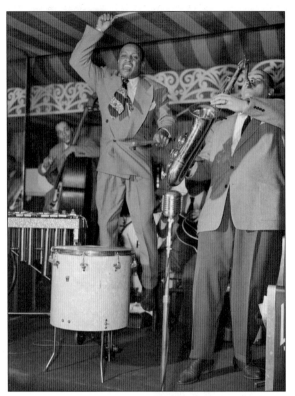

**LIONEL HAMPTON AND ARNETT COBB, AQUARIUM, JUNE 1946.** This is a picture of Lionel Hampton and tenor saxophonist Arnett Cobb. Cobb was from Houston, Texas, where his musical career began. He later moved to New York City and began playing with Lionel Hampton, a successful bandleader who was the most instrumental and innovative vibraphone player.

**COZY COLE PLAYING DRUMS, VOGUE ROOM, SEPTEMBER 1946.** Cozy Cole is seen in the background playing the drums. He was also a successful session drummer who can be heard playing on numerous hits. Highlights include playing with the Duke Ellington Orchestra.

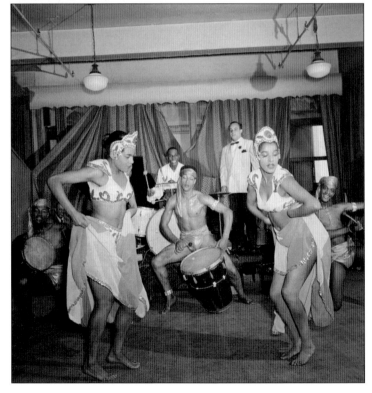

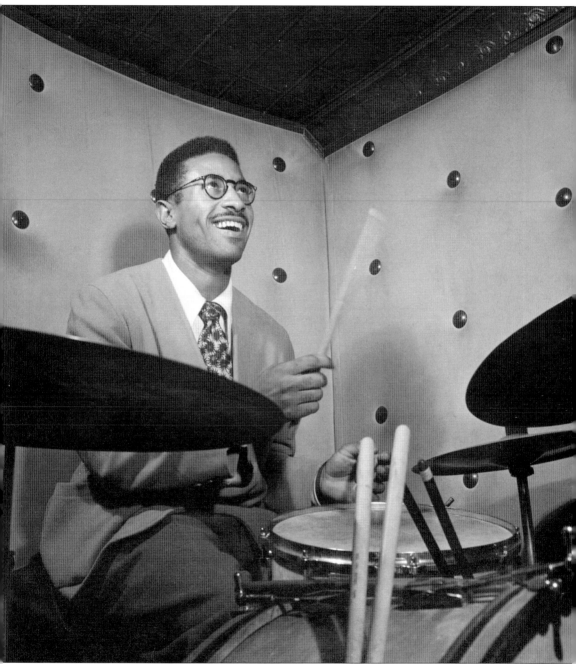

**MAX ROACH, THREE DEUCES, OCTOBER 1947.** Max Roach was a legendary drummer and composer. He was one of the early pioneers of bebop, working with Charlie Parker, Dizzy Gillespie, Coleman Hawkins, Stan Getz, Billy Eckstine, and Sonny Rollins. He could play any style of jazz and is recognized as one of the most important drummers in jazz history.

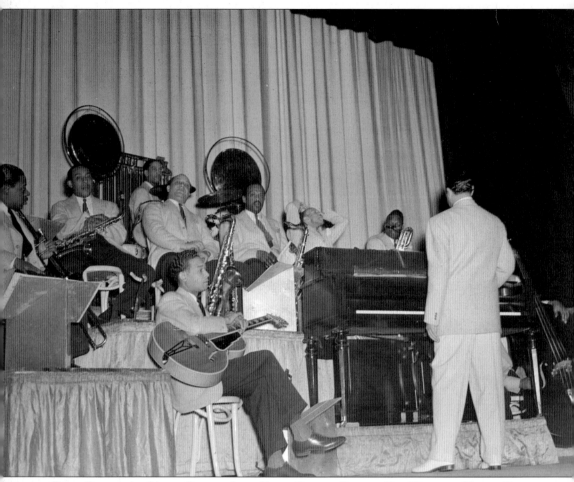

DUKE ELLINGTON, JUNIOR RAGLIN, JUAN TIZOL, BARNEY BIGARD, BEN WEBSTER, HARRY CARNEY, REX WILLIAM STEWART, AND SONNY GREER, HOWARD THEATER, 1940. Duke Ellington's career spanned his entire lifetime and included leading his orchestra, composing, and arranging movie scores, hit musicals, and world tours. He discovered many huge jazz musicians, including Django Reinhardt, Ella Fitzgerald, and Billy Strayhorn. Most of his songs became jazz standards. He was known for his eloquence and charisma.

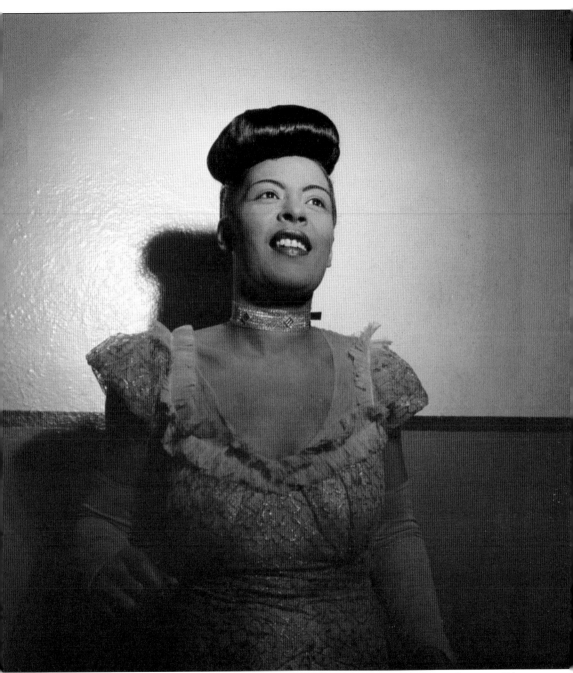

**BILLIE HOLIDAY, CARNEGIE HALL, 1946.** In this photograph, Billie Holiday is at the top of her career. She is seen here at a sold out show at Carnegie Hall in New York. At this time, Holiday placed second in the *Down Beat* magazine poll for 1946, and in 1947, *Billboard*'s July 6 issue ranked Holiday No. 5, her highest ranking in the poll, on its annual college poll of girl singers. In 1946, Holiday won the *Metronome* magazine popularity poll.

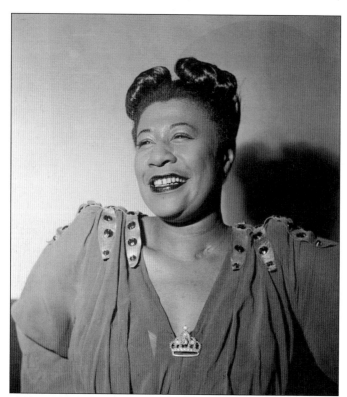

**ELLA FITZGERALD.** After winning a talent contest at the Apollo Theater, Fitzgerald started working with drummer and bandleader Chick Webb. She was soon signed to the Decca label and appeared regularly in Norman Granz's Jazz at the Philharmonic concerts. With the demise of the swing era and touring big bands, a major change in jazz music occurred. The advent of bebop led to new developments in Fitzgerald's vocal style with Dizzy Gillespie's big band. She started scat singing, and her 1945 recording of "Flying Home" was one of the most influential records of all time.

**MARY LOU WILLIAMS'S APARTMENT, NEW YORK, NEW YORK, AUGUST 1947.** From left to right, Dizzy Gillespie, Tadd Dameron, Mary Lou Williams and Jack Teagarden are at Williams's apartment in New York. Mary Lou Williams was one of the few female singer, composers, and arrangers in this period of jazz. She had an extensive background in classical music and was a great arranger due to her expert knowledge in music theory and composition. She had a huge impact on the birth of bebop and was close friends with Thelonious Monk and Charlie Parker.

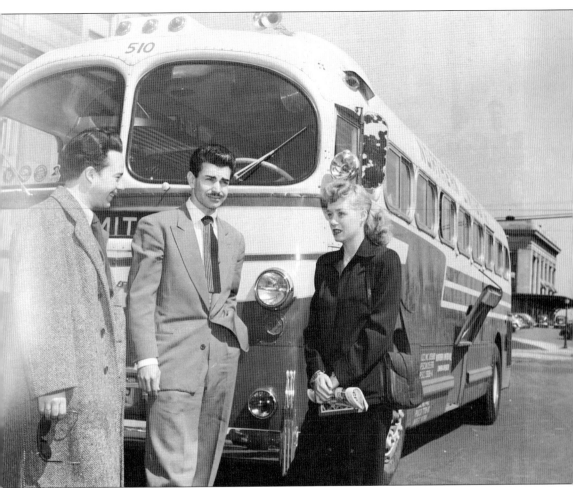

**CHICO ÁLVAREZ (CENTER) AND JUNE CHRISTY (RIGHT) WITH UNIDENTIFIED MAN, 1947.** June Christy was a singer known for her work in cool jazz and was nicknamed "the girl with the silky smooth vocals." Her success as a singer began with the Stan Kenton Orchestra. She gained success as a soloist on her debut album *Something Cool*. She was one of the most innovative singers of her time.

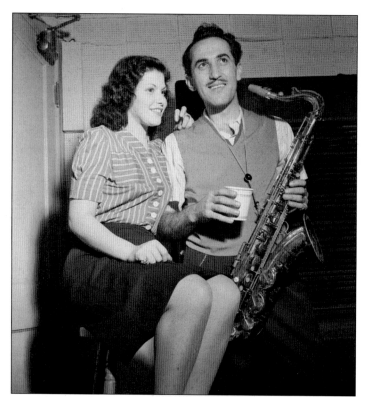

**LILYANN CAROL, OCTOBER 1946.** Lilyann Carol sang with Charlie Ventura and his orchestra, and in 1946, they scored a big hit with their rendition of "How High the Moon," with the flip side "Please Be Kind." They played together for 10 years at the Famous Hickory House Club on Fifty-second Street.

**VIVIEN GARRY, DIXON'S, MAY 1947.** Vivien Garry was the only female jazz bassist on Fifty-second Street. She was the bandleader of the Vivien Garry Quintet, with Edna Williams on trumpet and Ginger Smock on violin, and also the Vivien Garry Trio, with her husband, Arv Garrison, on guitar and Wini Beatty on piano. They were breaking new ground with their revolutionary band lineup.

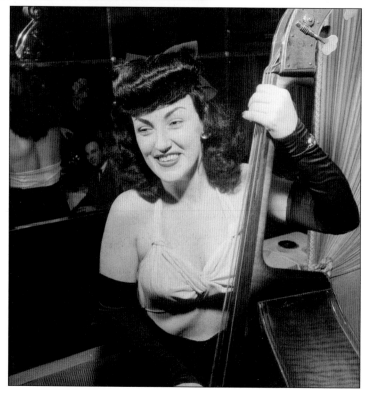

**HARPIST OLIVETTE MILLER , CAFÉ SOCIETY, 1947.** From left to right are Cliff Jackson, Gene Sedric, Olivette Miller, and Josh White. After having served in Europe for 14 months during World War II, Olivette returned to the United States and to jazz.

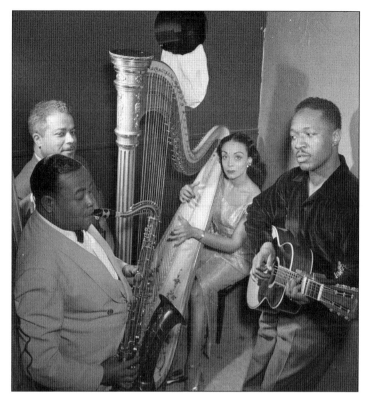

**ETHEL WATERS, 1942.** Ethel Waters was not only an amazing actress but also an amazing singer who sang blues, jazz, and gospel. She began her career in the 1920s singing blues, later performing jazz, big band, and pop music on the Broadway stage and in concerts. Her signature song was "Stormy Weather," which Lena Horne also sang.

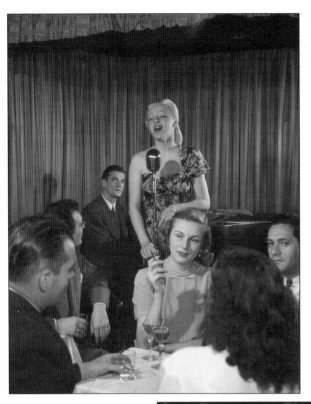

**CHINA DOLL NIGHTCLUB ON FIFTY-SECOND STREET, C. 1948.** Taken by photographer William P. Gottlieb, this picture is of China Doll Nightclub during the height of New York City's golden era of jazz. Gottlieb grew up in Brooklyn and later moved to Bound Brook, New Jersey. One night, while on Fifty-second Street with a friend, he got his start as a photographer by simply taking pictures of the jazz scene for fun.

**PIANIST BUNTY PENDLETON AND DRUMMER BABY DODDS ON A HUDSON RIVER RIVERBOAT, JULY 1947.** Bunty Pendleton was one of the few female musicians to have a successful career in jazz in its heyday. Bunty, the wife of *New York Daily News* music reporter Bob Sylvester, is jamming with the Hodes-Blesh group. Not pictured but also performing at this riverboat concert was Marty Marsala on trumpet.

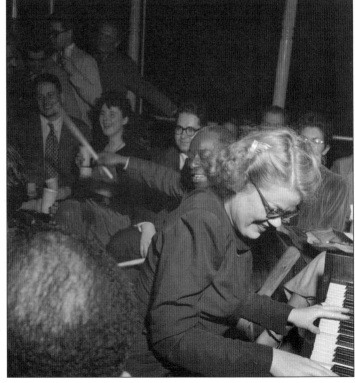

**TEDDY KAYE, VIVIEN GARRY, AND ARVIN "ARV" CHARLES GARRISON, DIXON'S, MAY 1947.** Teddy Kaye played the piano in the Vivien Garry Trio, which played all over Manhattan's top jazz nightclubs in the 1940s. Vivien Garry led the trio, and her husband, guitarist Arv Garrison, managed the group. This was the beginning of women gaining attention as musicians in the genre of jazz.

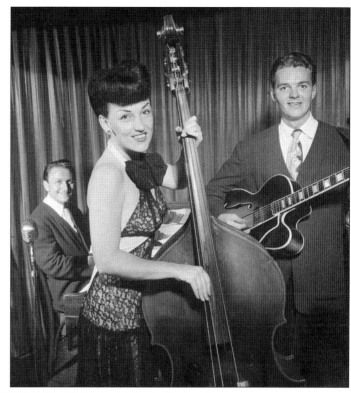

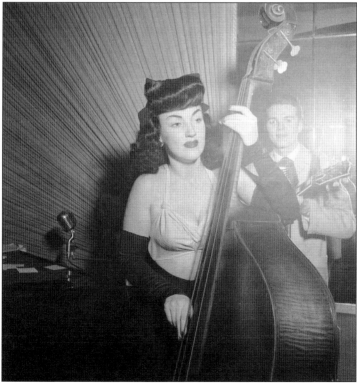

**VIVIEN GARRY AND ARV GARRISON, DIXON'S, MAY 1947.** Guitarist Arvin "Arv" Charles Garrison worked throughout his career as a session musician as well as recording his own solo efforts. He was one of the most liked musicians of his era and worked with all the big names. He worked the longest with the Vivien Garry Trio. Vivien Garry was the only female bass player that performed on Fifty-second Street.

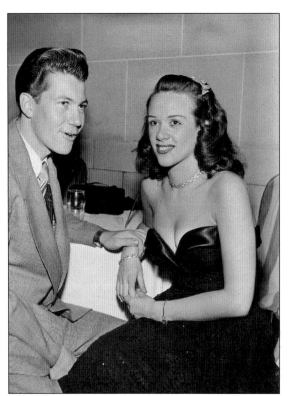

**FRAN WARREN AND GENE WILLIAMS, HOTEL PENNSYLVANIA, OCTOBER 1947.** Fran Warren and Gene Williams sang duets with a lot of the popular big bands that played at the Hotel Pennsylvania; they were a very popular duo that sang on the hotel circuit. Some of the orchestras that they sang with included Benny Goodman, Glenn Miller, Artie Shaw, and Tommy Dorsey. Fran Warren was a popular big-band era singer who achieved her greatest success with the hit song, "A Sunday Kind of Love," on Columbia Records and performed live on the *Ed Sullivan Show.* Fran came to New York at the age of 16 to audition for the Duke Ellington Orchestra but did not pass her audition. She did sing with Billy Eckstine's Orchestra, Charlie Barnet, Claude Thornhill and Randy Brooks.

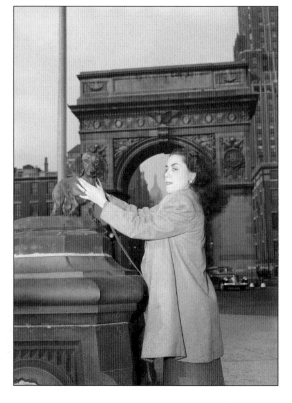

**ANN HATHAWAY, WASHINGTON SQUARE, MAY 1947.** Ann Hathaway was a very famous singer in New York in the late 1940s. She sang popular songs and ballads and worked in television and radio. Some of the orchestras that she worked with were those of Benny Goodman, Glenn Miller, Artie Shaw, and Tommy Dorsey. Ann Hathaway will be remembered as a great singer of the late 1940s.

**DORIS DAY AND KITTY KALLEN,
CENTRAL PARK, APRIL 1947.** As a
singer for a big band, Doris Day, started
her career in 1939. She became well
known after her song "Sentimental
Journey" in 1945. She would leave Les
Brown to embark on a successful solo
career. She had a long-lasting career
with her only recording label, Columbia
Records, which made Doris Day one of
the most popular singers in the world.

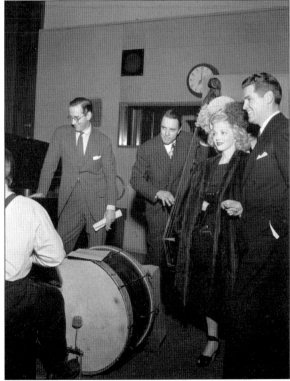

**JOAN BROOKS AND BENNY GOODMAN
AT THE CBS STUDIO, NEW YORK
CITY.** Joan Brooks was a very
successful singer in New York in the
late 1940s. She sang popular songs
and ballads and worked in television
and radio. Joan Brooks is sometimes
referred to as "The Girl With The
Voice You Won't Forget," or "vocally
challenged." Her popular songs
included "Good Night, Wherever,"
and "Someday, Somewhere." Brooks
started her career singing with the
Jolly Coburn Orchestra society band.
She was then hired by CBS to sing
on radio broadcasts backed by the
Archie Bleyer Orchestra. When the
jazz scene in New York began to fade,
Brooks went to Hollywood and had
small parts in western "B" movies.
Brooks married NBC executive
and record producer Bob Kerr, and
together they created and produced
their own popular broadcast, WKER.
Joan Brooks also sang on many
jingles for radio and television.

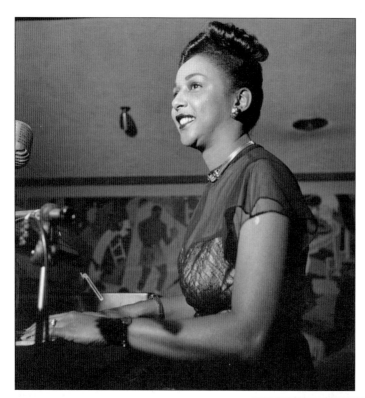

NORMA SHEPHERD SINGING AT THE DOWNBEAT, 1945. Norma Shepherd was a popular singer who performed in the clubs throughout Manhattan and on Broadway, television, and radio. She was a gospel and blues singer. In addition to being a great piano player, she was able to arrange music. She worked with many artists, like Duke Ellington, Count Basie, Cab Calloway, and many others.

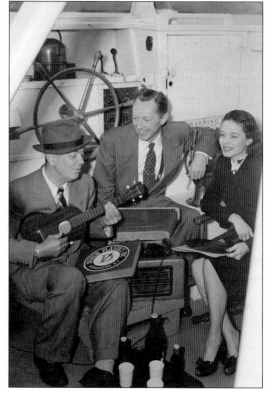

CLIFF EDWARDS, FRANK RAYE, AND BETTY BREWER ON THE HUDSON RIVER'S *UKELELE LADY,* JUNE 1947. Betty Brewer is pictured on the *Ukelele Lady* on the Hudson River with Cliff "Ukelele" Edwards (left) and Frank Raye (center). Betty was a beautiful singer who sang with Glenn Miller, Artie Shaw, and Tommy Dorsey and had a long singing career in television and radio. Cliff Edwards was a talented musician who was also the voice for Jiminy Cricket in the Walt Disney movie *Pinocchio.*

**DOTTIE REID.** Dottie Reid is pictured here singing at the club Dixon's. She was a very successful singer who sang with Benny Goodman and who had a huge success with her recording with him called "It's Only a Paper Moon." She was popular in New York in the late 1940s. She mostly sang ballads and worked in television and radio. She worked with a lot of well-known groups, like those of Benny Goodman, Buddy Rich, and Muggsy Spanier.

**NOLA'S AND ITS FAMOUS DANCERS.** Nola's was a jazz club that also mixed a lot of dance routines in with its regular lineup of musicians. It was known to have beautiful dancers who were the original chorus line. Many of the dancers were also Broadway performers, and a few went on to work in film and television.

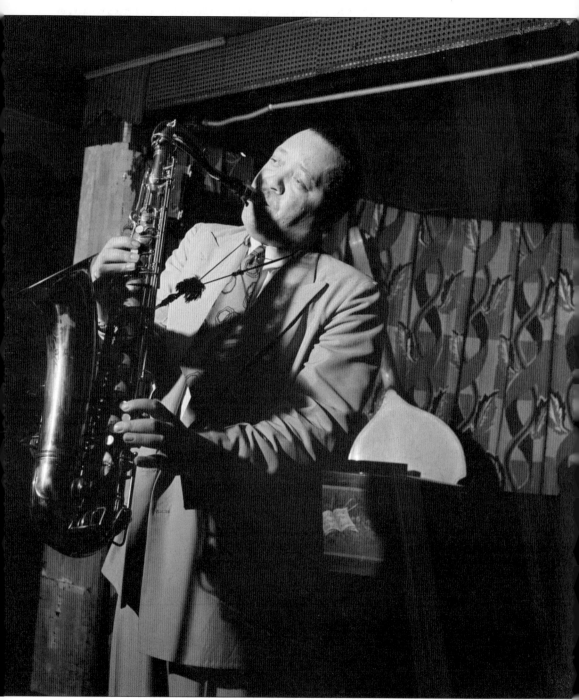

**LESTER YOUNG AT THE AQUARIUM, 1946.** Lester Young became a major star when he became a member of the Count Basie Orchestra. Young was a great friend of Billie Holiday and one of the most influential players of all time. He played with a smooth and cool tone and used sophisticated harmonies and fast catchy riffs that captivated everyone. He was famous for his hip innovative style and was nicknamed "the Prez" by Billie Holiday. He mastered the tenor saxophone, trumpet, violin, and drums.

JUNE CHRISTY, CLUB
TROUBADOR, 1947. June
Christy was a very successful
singer in New York and
was most recognized for her
work with the Stan Kenton
Orchestra in the late 1940s.
She had a voice that was
ahead of her time. She
often sang popular songs
and ballads and worked in
television and radio. Her
voice was a little on the
weak side, but her innovative
style and phrasing captured
the attention of many well-
known groups, like the
Stan Kenton Orchestra,
Charlie Barnet Orchestra,
Johnny Guarniera Quartet,
and Peggy Lee and the
Kentones. Her voice became
synonymous with cool jazz.

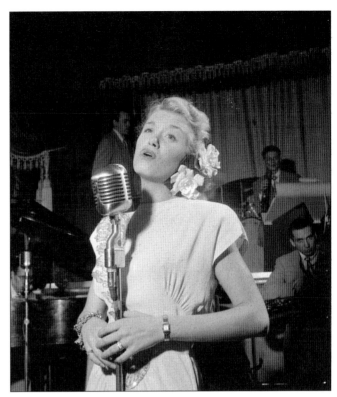

JOAN BROOKS AND DUKE NILES,
APRIL 1947. Joan Brooks was a singer
who sang with many of the leading
big bands and swing orchestras during
the 1940s. She was never considered
one of the great vocalists but steadily
worked as a singer before moving to
Hollywood to become an actress.

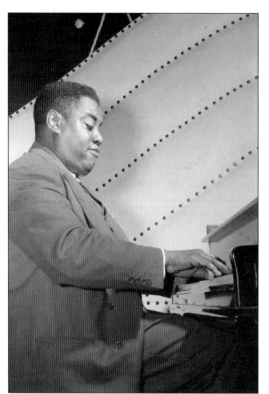

**ART TATUM, VOGUE ROOM, 1946–1948.**
Blind from birth, Art Tatum was an amazing jazz pianist. Influenced by Earl Hines and Fats Waller, he would create a unique playing style that incorporated swing piano riffs. He had amazing technique and harmonic control and played with lightening-fast speed. He was the most outstanding pianist in jazz when it came to solo performances.

**ERROLL GARNER.** Erroll Garner was born in Pittsburgh, Pennsylvania, and became one of the most exquisite jazz pianists of all time. His signature sound included his left-hand comping with beautiful octaves, which also became the signature sound of guitarist Wes Montgomery, who perfected the use of octaves in his solos. His signature song and biggest hit was "Misty." He started his career in New York with the Slam Stewart trio and quickly developed his own style and attracted a huge following. He backed Charlie Parker on his famous *Cool Blues* session in 1947.

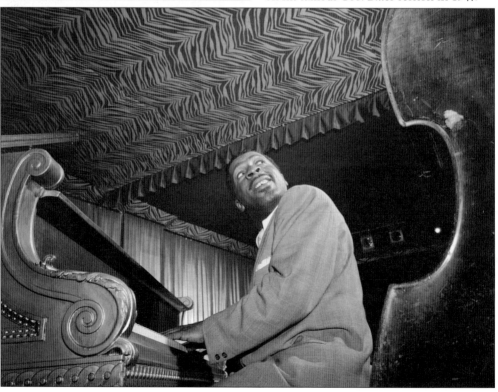

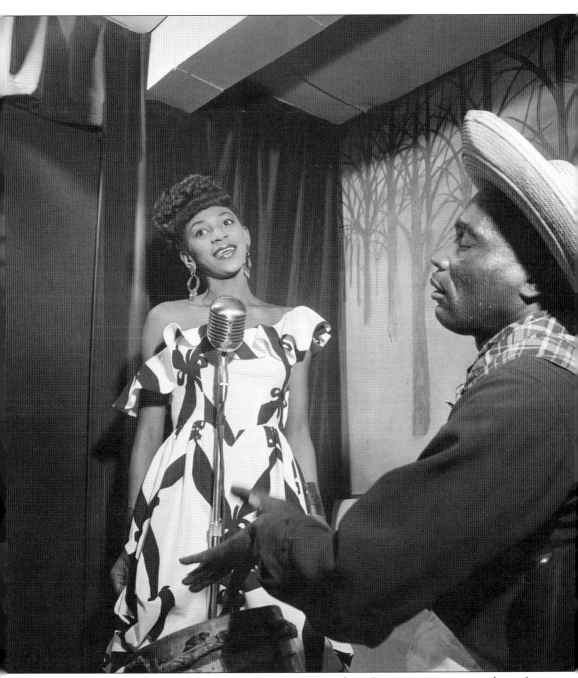

**JOSEPHINE PREMICE, VILLAGE VANGUARD, JULY 1947.** Josephine Premice was a major talent of Haitian descent who grew up in Brooklyn. She made her Broadway debut in a show called *Blue Holiday*, costarring Ethel Waters. She was also a successful jazz singer and played at the Café Society on a regular basis. Josephine was nominated for a Tony Award for her character Ginger in the musical *Jamaica*, starring Lena Horne. She worked with all of the greatest jazz musicians of this era.

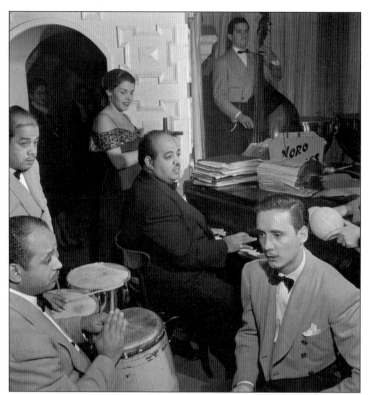

**NORO MORALES AND HUMBERTO LÓPEZ MORALES, GLEN ISLAND CASINO, JULY 1947.** Noro Morales, pictured sitting at the piano, mastered several instruments as a child. He was a prodigy who played in Venezuela from 1924 to 1930, then returned to Puerto Rico to play with Rafaél Munoz. In 1940, he came to New York City to pursue his dreams as a Latin bandleader. Noro formed a successful band with his brothers Humberto (left front, on drums) and Esy, becoming the Brothers Morales Orchestra.

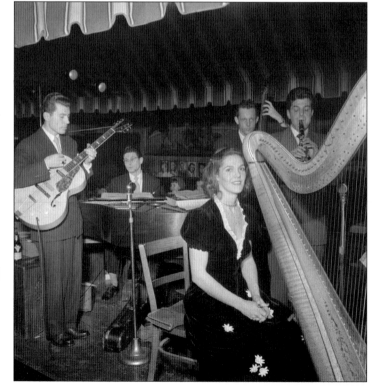

**JOE MARSALA AND ADELE GIRARD, HICKORY HOUSE, 1946–1948.** Joe Marsala, seen standing behind the harp, was a clarinetist and songwriter. Born and initially based in Chicago, Marsala moved to New York City in 1933 at the request of Wingy Manone. It was in New York City that Joe found his greatest success as the leader of the 1936 band that entertained the Hickory House on Fifty-second Street. He remained there as leader for 10 years.

**NORO MORALES, GLEN ISLAND CASINO, JULY 1947.** Noro Morales played a major role in the bebop movement. At the height of his popularity, he was recording rumba music with his sextet. His unique use of the piano, as both melody and rhythm, was highly innovative at the time and greatly influenced Charlie Parker, Dizzy Gillespie, and Thelonious Monk.

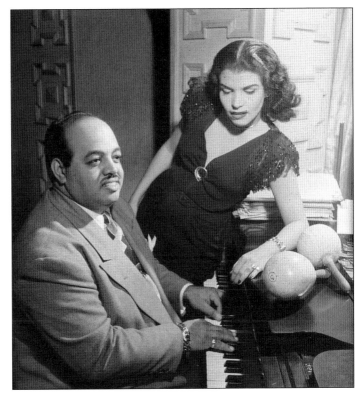

**MACHITO GRILLO, JOSÉ MANGUAL, CARLOS VIDAL, AND GRACIELA GRILLO, GLEN ISLAND CASINO, JULY 1947.** In New York City, Machito Grillo formed the band Afro-Cubans with Mario Bauzá as musical director. They blended Cuban rhythms and big band arrangements to form a whole new sound. He made many recordings with his foster sister Graciela as singer. Machito's music had a major influence on the development of neon and "Cubop."

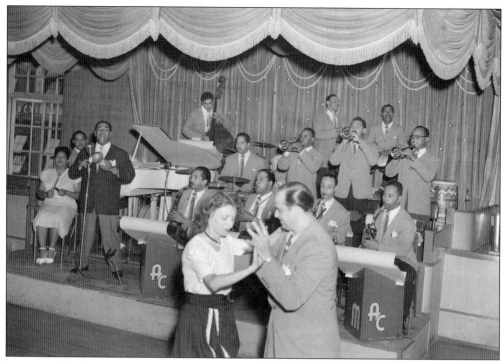

**MACHITO AND GRACIELA GRILLO AND MARIO BAUZÁ, GLEN ISLAND CASINO, JULY 1947.** Machito Grillo was an influential Latin American jazz musician who helped introduce Afro-Cuban jazz and was known as the creator of Cubop, which mixed Cuban, swing, salsa, and bebop styles of music. He grew up in Havana, Cuba, with the singer Graciela Grillo, who was his foster sister. They were a musical team their entire lives and quickly captured the attention of Charlie Parker and Dizzy Gillespie.

**LAWRENCE BROWN, CLUB DOWNBEAT.** Lawrence Brown was the nicest man in jazz. He was an amazing trombonist from Kansas who achieved his much-deserved recognition with Duke Ellington's orchestra. Brown was always busy and worked as a session musician as well as recorded his own solo efforts. He was one of the most liked musicians of his era. He was a bandleader and music arranger for many top bands.

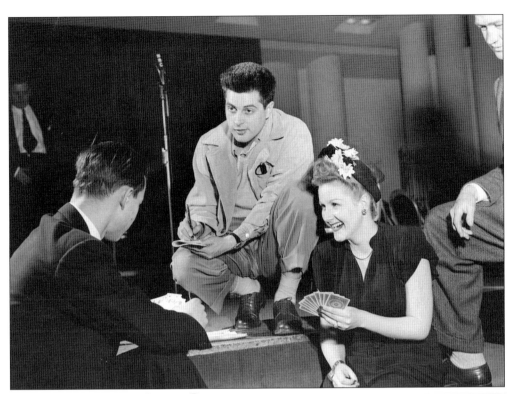

**MARGARET WHITING AND JOHNNY DESMOND (CENTER), 1947.** Margaret Whiting was the daughter of songwriter Richard Whiting and was born to be a star. She was groomed to become a wonderful vocalist and actress and would follow in her famous father's footsteps. Margaret grew up surrounded by legendary songwriters, like Harold Arlen, Johnny Mercer, Jerome Kern, and the Gershwin brothers. As a child, she would often sing at family parties in her living room with Johnny Mercer, Harold Arlen, Judy Garland, and Mel Tormé.

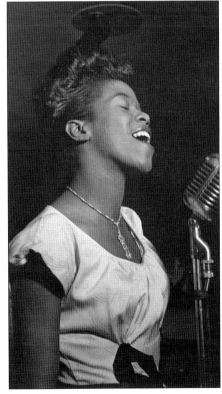

**SARAH VAUGHAN, CAFÉ SOCIETY DOWNTOWN, AUGUST 1946.** Sarah Vaughn was from Newark, New Jersey, and went from rags to riches after winning an amateur contest at Harlem's Apollo Theater in 1942. She was soon hired by Earl Hines's big band as vocalist and pianist. After working in Billy Eckstine's band, she became enticed with the new bebop style and began recording with Dizzy Gillespie and Charlie Parker in 1945. Her unique voice with its vast range, wide vibrato, and harmonic sensitivity enabled Vaughan to use her voice as an instrument. She could even improvise as a jazz soloist by just using her voice. She is one of the most remarkable jazz singers of all time.

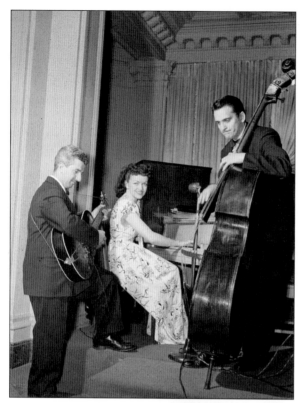

DARDANELLE, GUITARIST JOE SINACORE, AND BASSIST BERT NAZER, SHERATON HOTEL, JULY 1947. Dardanelle was just one of the few women to play instruments on Fifty-second Street during the 1940s. Dardanelle was one of the leading women jazz instrumentalists, playing vibes and piano. Here, she is playing with Joe Sinacore and Bert Nazer at the Sheraton Hotel's Satire Room in New York City.

MARION HUTTON. Marion Hutton was a very successful singer who sang with the orchestras of Vincent Lopez, Glenn Miller, and Desi Arna.

**Jo Stafford, July 1946.** This photograph, taken in a dressing room at the Zanzibar by Bill Gottlieb, is of singer Jo Stafford. The beautiful and exotic perfume bottles were part of her collection, and she was one of the first entertainers to make her own fragrance. Jo Stafford was a popular singer-songwriter and wrote songs for Tommy Dorsey and Nat King Cole. Her biggest hit was "You Belong to Me," and it made her a huge star. Another one of her famous recordings was "Diamonds Are a Girl's Best Friend," which was later turned into a movie starring Marilyn Monroe.

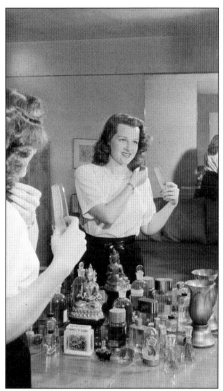

**Tadd Dameron, Mary Lou Williams, and Dizzy Gillespie, August 1947.** From left to right, Dameron, Williams, and Gillespie are pictured at Mary Lou Williams's apartment in New York City. Mary Lou Williams (May 8, 1910–May 28, 1981) wrote and arranged for Duke Ellington, Benny Goodman, Count Basie, Charlie Parker, and Thelonious Monk and was the only female musician who made a significant contribution to the creation of bebop. Having written hundreds of compositions and arrangements and recorded more than 150 records, Williams was a Grammy Award recipient.

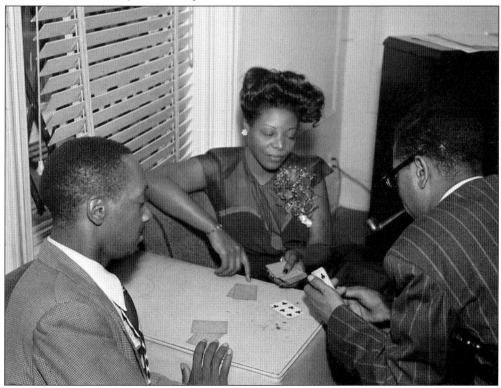

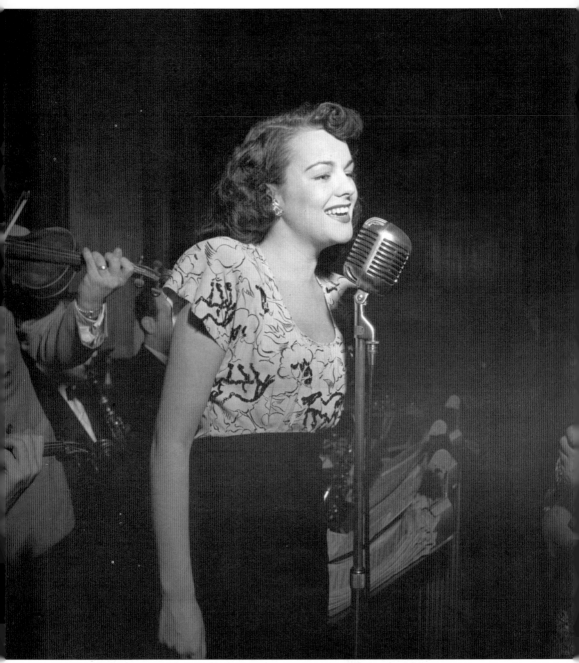

**VOCALIST FOR JUSTIN STONE'S ENSEMBLE, ZANZIBAR, 1946.** Justin Stone came to prominence while a member of Count Basie's orchestra. Justin Stone would move on to become a successful big band conductor in the 1940s; he always had a beautiful singer. He later pioneered the meditation form T'ai Chi Chih (TCC). While working in this discipline, he composed very soothing and gentle music to support the peacefulness and serenity of the TCC movement. He is the father of new age–style music—50 years ahead of its time.

**JEANNE CUMMINS SINGING WITH THE BERNIE CUMMINS BIG BAND.** Ohioan Jeanne Cummins began her singing career at the age of eight years old. In this photograph, she is singing with the Bernie Cummins Band, which was a favorite at the New Yorker Hotel. She was very close to her mother, who designed all of her clothes and traveled with her to every show. Eventually, Jeanne would marry Walter Cummins, the guitar player for his brother's band. (Courtesy of the Walter and Jeanne Cummins's Children Collection.)

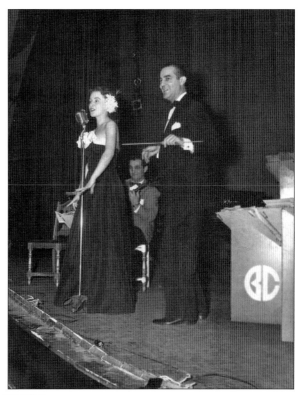

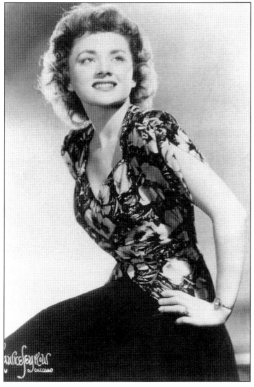

**JEANNE CUMMINS, 1946.** Jeanne Cummins was a beautiful singer who was sent to Hollywood, which was where this picture was taken of her. It is in the display case in the New Yorker Hotel as one of its featured singers. Jeanne Cummins had a long career in show business, and when she and her husband, Walter Cummins, were raising their family, she continued to work in local television and radio in Ohio, where they owned a string of bakeries. (Courtesy of the Walter and Jeanne Cummins's Children Collection.)

**CLUB NOCTURNE ON FIFTY-SECOND STREET.** This photograph shows the changing times in the late 1940s. Nocturne was a mixed venue of small-combo jazz, dancing, and burlesque. This was the beginning of the end of the jazz clubs that were on Fifty-second Street. They were all soon replaced with strip clubs and descended joints, leaving some well-known musicians out of work.

**ANN HATHAWAY, CAFÉ SOCIETY DOWNTOWN, 1947.** Ann Hathaway was a wonderful singer in New York in the late 1940s. She sang popular songs and ballads and worked in television and radio. Some of her highlights include singing for Benny Goodman, Glenn Miller, Artie Shaw, and Tommy Dorsey. Ann Hathaway always traveled with her dachshund and is often seen photographed with him.

**TEDDY KAYE (ON PIANO) AND VIVIEN GARRY, DIXON'S, MAY 1947.** The Vivien Garry Trio, including Kaye, Garry, and Charles Garrison, performed throughout New York in live shows as well as worked as session musicians. Vivien Garry was a rare sight in the New York City jazz clubs during this era because no one had ever heard of a female bass player before. She was one of the most well-liked musicians and worked with all the big names. Dixon's Nightclub has been gone for years, but in the 1940s, it featured the best jazz musicians and had an open door for female musicians.

**ZANZIBAR CAFÉ.** The Zanzibar Café was owned by Joe Howard and was located inside the famous Brill Building on Fiftieth Street and Broadway. It was an exotic nightclub that allowed all musicians and patrons to work together. It attracted the rich and the beautiful and was not an easy club to get into. It was the hottest ticket in town—with real leopard-skin couches and a stage that featured everyone from Charlie Parker, Miles Davis, Bill Evans, Billie Holiday, and Thelonious Monk to Miles Davis, Dizzy Gillespie, and Django Reinhardt. (Author's photograph.)

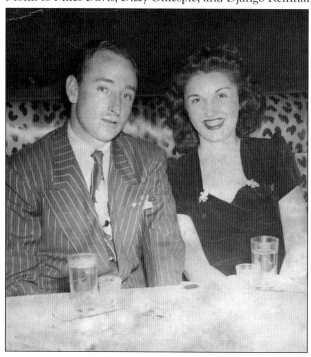

**ELIZABETH AND RICHARD, ZANZIBAR CAFÉ.** Seen here are Elizabeth and Richard Dodd at the Zanzibar Café in 1947. At the time of this photograph, Richard had just returned from the South Pacific after serving in the US Army during World War II. They were celebrating the publishing of Richard's song "Out of the Darkness," which was being produced by Hoagy Carmichael, and their engagement. Elizabeth was only 18 years old when Richard proposed. This picture was sent out to everyone as a thank-you after their wedding at Mount Carmel in Bayonne, New Jersey, on September 29, 1947. (Author's photograph.)

# *Four*

# HEARTSTRINGS

**GUITARIST PAT MARTINO.** Pat Martino is a legendary guitarist that just released two new albums and a book about his years as a musician. He is a world-class guitarist who is fast, complex, and innovative. He continues to influence aspiring guitarists from around the world. He has played with many of the legends featured in this book and has received many Grammy Awards for his music. Pat was first exposed to jazz through his father, Carmen, who studied guitar with Eddie Lang. When Pat was a kid, his dad took him to all the hot spots on Fifty-second Street to hear and meet Wes Montgomery and other musical giants. Pat Martino studied guitar with Dennis Sandole and later became friends with a gifted student, John Coltrane, who would treat Pat to hot chocolate as they talked about music. His main influences are Johnny Smith, Stan Getz, Wes Montgomery, and John Coltrane. (Courtesy of Pat Martino.)

**OSCAR PETTIFORD (LEFT) AND JUNIOR RAGLIN, AQUARIUM.** Oscar Pettiford gained success in 1942 when he joined the Charlie Barnet band. He gained even more success when he recorded with Coleman Hawkins on his 1943 "The Man I Love" recording. In addition, Pettiford performed with Earl Hines, Duke Ellington, Woody Herman, and Ben Webster and even paired with Dizzy Gillespie in a bop group in 1943. Starting in 1945, Pettiford again worked with Coleman Hawkins, but this time on movie sound tracks.

**WES MONTGOMERY.** Wes Montgomery's style has been described as smooth, rich, and lush. Born into a musical family in Indiana, Wes released a number of albums with his brothers Monk and Buddy. Having first picked up the guitar at age 20, Wes learned by listening and playing by ear the recordings of his idol, Charlie Christian. Lionel Hampton witnessed Wes's ability to replicate Christian's solos and hired him. His octave solos were exquisite and earned him his signature sound. Famous guitarists that credit him as a major influence include Stevie Ray Vaughan, Joe Satriani, Jimi Hendrix, Eric Clapton, Pat Martino, Larry Coryell, and Pat Metheny. (Author's photograph.)

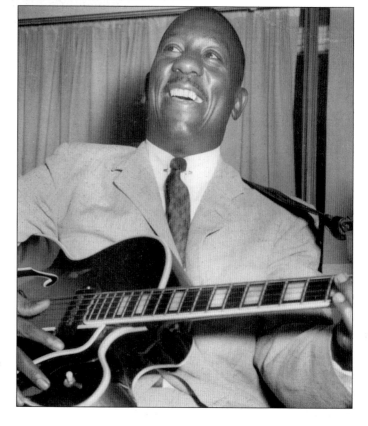

**JERRY TOPINKA, GUITARIST.** Jerry Topinka is an up-and-coming guitarist that was influenced by the guitar styles of Django Reinhardt, Wes Montgomery, Charlie Christian, and countless others. Jerry's CD *Summer Nights* captivates the listener with his melodic and intricate playing style. Jerry began studying guitar with Al Caiola and Joe Cinderella. At the age of 16, Jerry began playing professionally, and Les Paul used to come and see him play. They became good friends, playing venues such as the Iridium in New York City. Jerry toured the country with Buddy Rich and Gloria Gaynor. He accompanied Stephanie Mills and recorded a duet of "Danny Boy" with Al Green. He recently worked with A.R. Rahman, the acclaimed Indian performer and composer who won a Golden Globe and three Academy Awards for his music in *Slum Dog Millionaire*. He is an amazing guitarist and a name to watch out for as he continues to perform throughout New York and New Jersey. He is also a wonderful teacher. (Courtesy of Jerry Topinka.)

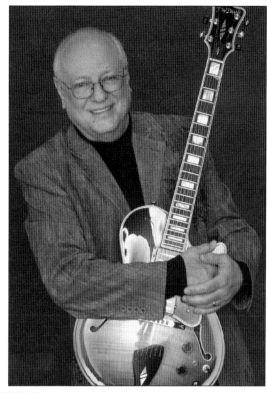

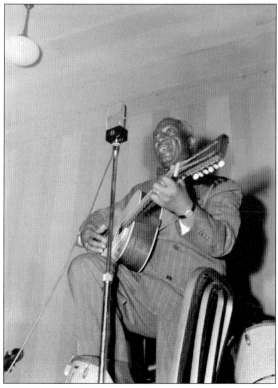

**LEADBELLY, NEW YORK, NEW YORK, JUNE 1946.** This is a picture of Huddie William "Leadbelly" Ledbetter (January 20, 1888–December 6, 1949). He was a blues guitarist, singer, and composer who got his start in some of the nightclubs along Fifty-second street. His unique style of blues, folk, jazz, and early Americana would influence the next musical movement that was happening in Greenwich Village. He was a master of the 12-string guitar and introduced a whole new style of folk standards. He was the inspiration of the Allman Brothers' song "Rambling Man." His style predated Son House and Robert Johnson. He served time in a Southern prison, and after he was released, he moved to New York and wrote folk songs with Woody Guthrie, Memphis Slim, Josh White, Sonny Terry, Brownie McGhee, and others. His favorite themes used in songs include wild women, prison life, racism, and cowboys.

**ELIZABETH DODD BRINKOFSKI, MOZAMBIQUE.** This is a modal guitar jazz CD that was recorded live with a group of student musicians from Rutgers University. An original song "Tides" won an Honorable Mention Billboard Award. Elizabeth was signed to legendary music Abby Hoffer Enterprises and performs with the gospel group Amoji Amani Songsters. She can be seen at Smalls, the Village Vanguard, and B.B. Kings in New York City. She studied with Harry Leahey and is often compared to Emily Remler. (Author's collection.)

**MONKEY BAR.** This is a picture of the famous Monkey Bar, which still exists today. It was once a place where all of the famous jazz musicians would go to hang out when they were not playing. There was always a great piano player performing there; its piano bar was where Art Tatum and Bill Evans first got their starts. It is located next to the Hotel Elysée on Fifty-fourth Street in New York City. (Courtesy of Monkey Bar.)

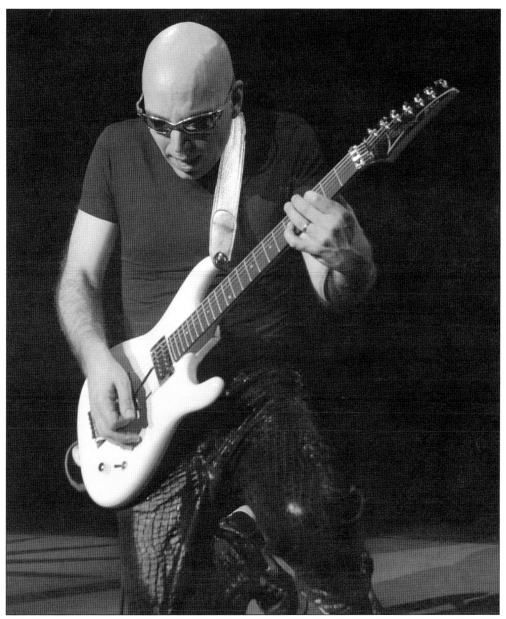

**JOE SATRIANI.** Joe Satriani is a world-class guitarist and multi–Grammy Award recipient who was also the teacher of Steve Vai among many other major players. He was influenced by Wes Montgomery, Charlie Christian, Miles Davis, Charlie Parker, and Jimi Hendrix. For his first solo tour in 1988, Mick Jagger hired Satriani as lead guitarist. In 1994, Satriani was the lead guitarist for Deep Purple. Without a doubt, Joe Satriani is one of the most accomplished guitarists that was born and bred in New York and who was influenced by all of the great musicians from Fifty-second Street. He credits Wes Montgomery, Les Paul, Charlie Christian, and Jimi Hendrix as his influences. He is one of the only guitarists who was able to blend jazz, classical, blues, rock, medal, modal, bebop, Indian, and fusion and come up with a new and beautiful voice. His solo album, *Not of This Earth*, was a jaw-dropping moment for every guitar player. He just released the new studio album, *Unstoppable Momentum*. (Courtesy of Steve Jennings.)

**GERRY MULLIGAN.** In September 1948, Gerry Mulligan was part of Miles Davis's nine-piece band, which also featured Bill Evans and John Lewis. Mulligan played baritone saxophone alongside Miles Davis on the trumpet. They will go down in history as one of the most influential groups in jazz history, creating a sound that, despite its New York origins, became known as West Coast sound. The success of this group led to a compilation record with Capitol Records titled *Birth of Cool*. Mulligan arranged and wrote "Rocker," "Venus de Milo," and "Jeru," all found on the record.

**ARTIE SHAW ORCHESTRA.** Artie Shaw was regarded as "one of jazz's finest clarinetists." He was the bandleader of one of the well-known big bands in the late 1930s through the early 1940s. His band's most popular song was a cover of Cole Porter's "Begin the Beguine." (Courtesy of New Jersey Jazz Society.)

*The Artie Shaw Orchestra*
Under the direction of Dick Johnson

ERIC CLAPTON. "Slowhand" was a nickname Eric Clapton earned while playing with John Mayall & the Bluesbreakers. He is one of the most important and influential guitarists of all time and was recently ranked as No. 2 in the *Rolling Stone*'s "100 Greatest Guitarists of All Time." Slide guitar has never come close to the unbelievable songs found on Eric Clapton's record with Duane Allman. Eric is the only person to have been inducted into the Rock and Roll Hall of Fame three times; he has also received 17 Grammy Awards. When Clapton left the Yardbirds, he began playing with John Mayall. Clapton next joined the three-instrument band Cream with Ginger Baker and Jack Bruce. Two of his most popular recordings were "Layla" and "Crossroads." (Courtesy of Eric Clapton Management.)

**JIMI HENDRIX.** Jimi Hendrix was a genius! He grew up in Seattle, Washington, and was heavily influenced by Les Paul, Miles Davis, and many of the legendary jazz artists that became famous on Fifty-second Street. He was a brilliant guitar virtuoso and songwriter, having left his mark in rock, blues, and jazz. His signature sound earned him the reputation as "the greatest guitarist who ever lived." After leaving the Army, he began his professional musical career. In addition to organizing and playing in his own band, he performed backup for various soul, R&B, and blues musicians, including Wilson Pickett, Chuck Jackson, Sam Cooke, and the Isley Brothers. He next found success in Europe with the Jimi Hendrix Experience, Monterey Pop Festival, and Woodstock in 1969. He introduced the technique of feedback created by overdriven amplifiers with high volume and gain. He pioneered the wah-wah pedal and stereophonic phasing effects in rock, blues, and jazz music recordings. *Rolling Stone* ranked him as the greatest guitarist of all time and the sixth greatest artist of all time. (Jimi Hendrix Foundation and Jimi Hendrix Estate.)

**HARRY LEAHEY.** Harry Leahey (sitting, playing guitar) is seen here at Carnegie Hall with Gerry Mulligan (far left), Chet Baker (second from left), and Jack Six (far right). Leahey had just returned from a tour in Japan with Phil Woods. He always said that working with Phil Woods forced him to become an extremely fast player. He also had an amazing jazz trio that recorded the CD *Still Waters*. Harry Leahey was one of the greatest jazz guitarists of all time and maybe the most underrated guitarist, too. He has yet to be discovered! (Courtesy of Jimmy Leahey and Debbie Leahey.)

**WEST FIFTY-SECOND STREET, 2012.** This is a 2012 picture of the famous Swing Street, between Fifth and Sixth Avenues, in New York City. Almost all of the famous nightclubs are gone, and the 21 Club is the only remaining club that was around during the golden era of jazz. If one looks real hard, the old brownstones that changed the world of jazz forever are visible in this small two-block area. (Courtesy of Andreas Praefcke.)

# DISCOVER THOUSANDS OF LOCAL HISTORY BOOKS FEATURING MILLIONS OF VINTAGE IMAGES

Arcadia Publishing, the leading local history publisher in the United States, is committed to making history accessible and meaningful through publishing books that celebrate and preserve the heritage of America's people and places.

## Find more books like this at
## www.arcadiapublishing.com

Search for your hometown history, your old stomping grounds, and even your favorite sports team.

Consistent with our mission to preserve history on a local level, this book was printed in South Carolina on American-made paper and manufactured entirely in the United States. Products carrying the accredited Forest Stewardship Council (FSC) label are printed on 100 percent FSC-certified paper.

MADE IN THE USA